After Art

POINT

SERIES EDITOR Sarah Whiting

Kissing Architecture by Sylvia Lavin

After Art

David Joselit

Princeton University Press Princeton and Oxford

Published by Princeton University Press, 41
William Street, Princeton, New Jersey 08540
In the United Kingdom: Princeton University Press, 6
Oxford Street, Woodstock, Oxfordshire OX20 1TW
press.princeton.edu

Library of Congress Cataloging-in-Publication Data

Joselit, David.
 After art / David Joselit.
 pages cm — (Point)
 Includes bibliographical references and index.
 ISBN 978-0-691-15044-4 (hardcover : alk. paper) 1. Art—Psychology.
2. Art and society. I. Title.
 N71.J68 2012
 701—dc23

British Library Cataloging-in-Publication Data is available

Publication of this book has been aided by the History of Art Department,
Yale University.

This book has been composed in Helvetica and Scala
Printed on acid-free paper. ∞
Printed in China
10 9 8 7 6 5 4 3

Business art is the step that comes after Art

—*Andy Warhol*

Contents

Acknowledgments xi

Preface xiii

Image Explosion 1

Populations 24

Formats 55

Power 85

Notes 97

Credits 115

Acknowledgments

After Art is based on a series of three lectures, "States of Form," that I gave as Kirk Varnedoe Professor at the Institute of Fine Arts during the spring of 2010. I am grateful to everyone at the IFA who hosted me so graciously, especially Director Patricia Rubin, whose characteristic intelligence and engagement with my ideas was extremely gratifying, and Professor Priscilla Soucek, who worked so hard to make my temporary appointment at NYU possible. Christina Snylyk managed the lecture series beautifully, and Jason Varone was a wizard with media. I thank Emily Bakemeier, Deputy Provost at Yale, for smoothing the administrative hurdles in accepting this position. I have benefited from the generosity of colleagues who have shared their expertise with me: Virginia Rutledge was extremely helpful in discussing issues of copyright and image commons, Roger Buergel helped clarify several aspects of Ai Weiwei's work, *Fairytale*, Keller Easterling

assisted me in understanding the repurposing of architecture, and Francesco Casetti, with whom I taught a course related to this book in the spring of 2011, was ever a stimulating interlocutor whose ideas have inspired me. I am also grateful to the two anonymous readers of my first draft whose comments I have benefited from enormously.

Geoff Kaplan worked assiduously and imaginatively to crystallize my ideas into eloquent diagrams for this book. Stephanie Romeo did an amazing job as photo researcher. I am grateful to the History of Art Department at Yale, and especially the Department Chair, Professor Alexander Nemerov, for underwriting the costs of image rights and reproductions as well as making available a generous subvention. POINT series editor Sarah Whiting has been a pleasure to work with and has improved this book enormously. I am grateful to Hanne Winarksy for encouraging me to pursue this project as *After Art* and to Princeton University Press editor-in-chief Brigitta van Rheinberg and editor Alison MacKeen for their support. Christopher Chung and Kelly Malloy have been most helpful. Since *After Art* is a "sequel" of sorts to my book *Feedback: Television Against Democracy*, I want thank Roger Conover at MIT Press for his backing of that project.

As always, I am grateful for the support of my partner, Steve Incontro, who is patient, loving, and intellectually challenging. This book is dedicated to the memory of my mother, Jill S. Joselit.

Preface

Diagram 1. Designed by Geoff Kaplan.

There are three dominant attitudes toward images that parallel those pillars of grade school education—reading, writing, and 'rithmetic—with three Ds: derivative, dumb, and deceptive.

- *Derivative:* Images are thought to derive significance from external sources. Whether tethered to a historical era or a philosophical idea, they are treated as illustrations—as vessels for borrowed content.

- *Dumb:* Images are dismissed as merely intuitive—incapable of the rigorous formalization that transforms visual data into communicable knowledge. In an otherwise excellent book by Ian F. McNeely with Lisa Wolverton, *Reinventing Knowledge: From Alexandria to the Internet,* for instance, art is considered a form of "informal knowledge." In their preface McNeely and Wolverton state, "[Our book] hardly touches on informal knowledge, the type of knowledge we get from reading a newspaper, fixing a motorcycle, parenting a child, or creating a work of art."[1] The (widely shared) assumption of these authors is that visual intelligence is insufficiently disciplined to cross the threshold of "formal" (i.e., *genuine*) knowledge.

- *Deceptive:* As sources of pleasure, images *deceive.* They create the ideological fantasias that Guy Debord so lustily condemned in his 1967 manifesto, *The Society of the Spectacle,* and that critics from both the right and the left have loved to hate ever since. As spectacle, images are the opposite of knowledge—they are the epitome of ignorance.[2]

After Art will assert that images possess vast power through their capacity for replication, remediation, and dissemination at variable velocities. In order to exploit this power for progressive ends, it is necessary to understand the potency of images on their own terms rather than dismissing them as derivative, dumb, and deceptive. To this purpose, *After Art* will shift critical emphasis from art's production (and the corollary of artistic intention) to what images *do* once they enter circulation in heterogeneous networks. While

the prefix *after* signifies belatedness, it is not synonymous with the more commonly used prefix *post*, which, as in the vexed category *postmodern*, or its more recent successor, postmedium, indicates both the termination and transformation of a previous era and its signature styles.[3] *Post* leaves the art object in tact albeit transformed or negated, whereas *after* shifts emphasis to its effects—its power—under the conditions of circulation.

The term *image* is a slippery one. I will use it here to indicate a quantum of visual content (say a digital photograph) that can assume a variety of formats.[4] For instance, any digital photograph may remain a computer file, or be printed in a variety of ways on a variety of surfaces; it lends itself to editing with software like Photoshop, and it can be degraded in quality by emailing or uploading it. In short, an image is a visual byte, vulnerable to virtually infinite remediation. The icon that heads this preface, which appears in a sequence of diagrams punctuating *After Art*, was designed by Geoff Kaplan to signify a new, more productive understanding of the power of images. Here are three of its aspects:

- Eye and I: the letter *i* in the center of the icon suggests both a pupil and a pronoun, just as images combine sensory and conceptual forms of information that, together, constitute their connection or link with spectators.

- Scalability and transformation: Images are a form of information that may shift from two dimensions to three, from

tiny to huge, or from one material substrate to another, just as the image-icon in this book will move through several formats or situations in its sequence of diagrams.

- Power and currency: The icon approximates a plug where the *i* functions as a prong entering a disk. I will argue that images produce power—a current or currency—that is activated by contact with spectators. The more points of contact an image is able to establish, the greater its power will be.

Image Explosion

The scale at which images proliferate and the speed
with which they travel have never been greater.[5] Under
these conditions, images appear to be free, but they
carry a price. Commenting to the *New York Times* on
the 2010 rebound of Art Basel, the world's most pres-
tigious modern and contemporary art fair, American
collector Donald Rubell declared with no apparent
irony, "People are now realizing that art is an interna-
tional currency."[6] (The new museums designed for cit-
ies around the world by star architects like Frank Gehry,
Renzo Piano, Jacques Herzog, and Pierre de Meuron
would thus function as the art world's central banks.)
In a time of economic instability, precipitated by world-
wide financial failures since 2008, *people now see art as
an international currency*. Art is a fungible hedge. Its
value (at least the value of art sold at fairs like Art Basel,
in prestigious auction houses, and at blue-chip galler-
ies throughout the world) must cross borders as eas-
ily as the dollar, the euro, the yen, and the renminbi.
By definition, a currency moves freely (though not

without a price). It is an instrument invented to trans-
fer value easily and efficiently—and now, with the aid
of computers, almost instantaneously. Even the negli-
gible materiality of paper money has grown practically
obsolete—required only for a fraction of transactions.
Currencies are universal translators: they can assign
a value to every kind of commodity, whether goods or
services. In the 1990s a second type of universal trans-
lator gained prominence: digital technologies with the
capacity to transpose any work in sound, image, or text
into numerical sequences—into code. Contemporary
art and architecture are produced at the intersection
of these two universal translators—one that specifies
value, and the other that specifies form. But how can
we describe the aesthetics of a currency like art?

First, we must discard the concept of *medium* (along
with its mirror image, the postmedium), which has been
fundamental to art history and criticism for generations.
This category privileges discrete objects—even objects
that are attenuated, mute, distributed, or "dematerialized."
One of the goals of *After Art* is to expand the definition
of art to embrace heterogeneous configurations of rela-
tionships or links—what the French artist Pierre Huyghe
has called "a dynamic chain that passes through different
formats."[7] *Medium* and *postmedium* are not good analytic
tools for describing the hybridity of such chains or "cur-
rencies" of different states of form. Here we may take
a lesson from late capitalist business practices in which

virtually anything, from trash to home mortgages, may be "monetized"—in other words exchanged on an international market in an abstracted representational form. As Rubell described it, art has been monetized too—as a universal currency. This has had the unfortunate effect of vast commercialization, but it has had other effects too—namely, vesting images with an enhanced form of power, which *After Art* is dedicated to exploring.

Our first task in assessing what kind of currency art might be, or become, is to understand the dynamics of its circulation since by definition currencies are constituted through exchange. At this moment, there are two dominant positions vis-à-vis the circulation of art. Not coincidentally, they correspond to those that structure contemporary global politics. One is aligned to the world of Art Basel, as well as the preponderance of large Western museums: it is a belief in the free "neoliberal" circulation of images where open markets render art (as well as other streams of images ranging from television to tweeting) as a form of currency. The second attitude might be described as fundamentalist; it posits that art and architecture *are rooted to a specific place.*[8] Religious fundamentalism is defined by adherence to doctrine, as laid down in sacred texts. Image fundamentalism asserts that a visual artifact belongs exclusively to a specific site (its place of origin): that, for instance, the Parthenon sculptures sold to the British Museum in 1816 by Thomas Bruce, 7th Earl of Elgin (figure 1) (who

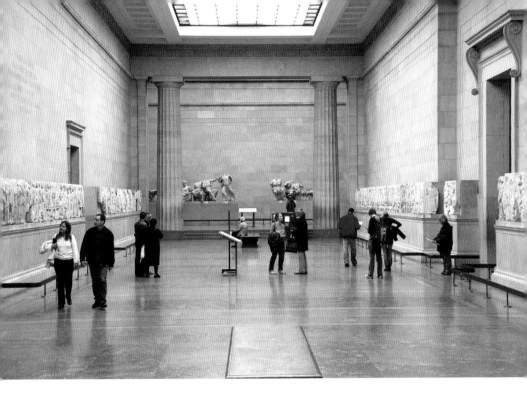

1. Elgin (Parthenon)
Marbles installed at
the British Museum,
London.

removed them from the Acropolis with dubious permission from the Ottoman Empire) should be returned to Bernard Tschumi's state-of-the-art Acropolis Museum, which opened in 2008 especially to draw these works back to Athens (figures 2, 3).

It is worth pausing to assert that this great political conflict—between neoliberalism and the fundamentalisms that have emerged in both the developed and developing worlds, and which encompass most major religions, including Christianity, Judaism, Islam, and Hinduism—is not merely *reflected* in art, but advanced by

it. Art has a diplomatic portfolio: it participates in building new public spheres, and in opening export markets abroad. Since 1979, to take one prominent example, Chinese contemporary art has been closely aligned with the ups and downs of domestic political liberalization through public exhibition—a practice that the artist Ai Weiwei has adapted to the Internet by, for instance, publishing troubling revelations on his blog about the

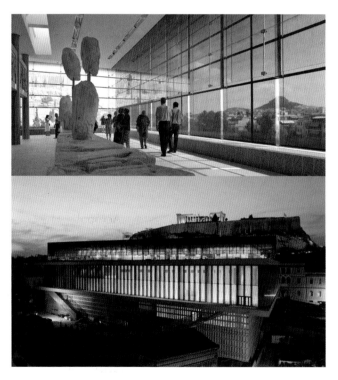

2. Bernard Tschumi, architect, Acropolis Museum, Athens. Installation shot of top gallery, showing where the Elgin (Parthenon) Marbles would be installed were they returned.

3. Bernard Tschumi, architect, Acropolis Museum, overall view of front of building at dusk.

tragic deaths of schoolchildren in poorly built schools in the great Sichuan earthquake of 2008.[9] It may seem that the Chinese art world's enthusiastic embrace of the art market disqualifies it as a political force, but in his provocative book *The Party and the Arty in China: The New Politics of Culture* (2004), political scientist Richard Curt Kraus argues the opposite. Kraus asserts that the success of Chinese artists in the international art market has led to reduced restrictions in the cultural realm and consequently greater political openness overall. As he declares, "Despite the violence of the 1989 Beijing Massacre, political reform in China has been more profound than is commonly recognized: artists (and other intellectuals) have established a new more autonomous relationship with the state. The price of this growing independence is financial insecurity, commercial vulgarization, and the specter of unemployment."[10] Given the crackdowns on dissident Chinese intellectuals after the public protests that characterized the so-called Arab Spring of 2011—including Ai's detention for eighty-one days for alleged economic crimes—Kraus's optimism may seem misplaced. However, it is clear that Ai's international reputation lead to pressure on the Chinese to release him, including efforts by German Foreign Minister Guido Westerwelle. If art has political efficacy in the twenty-first century, it may lie in cultural diplomacy as opposed to the invention of avant-garde forms as new content (figure 4).[11]

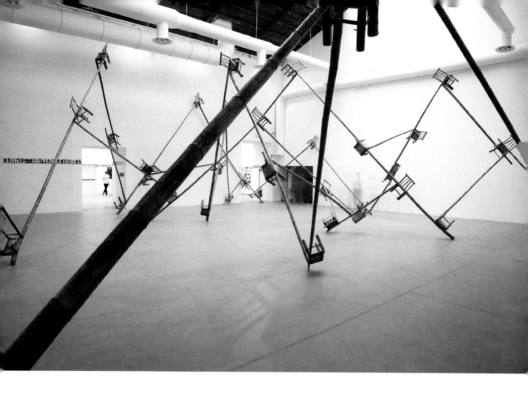

The debates surrounding repatriation of cultural property in the first decade of the twenty-first century constitute a very different sort of diplomatic dilemma. Though not fought over works of contemporary art, these controversies nonetheless offer a thoroughly contemporary conflict between a neoliberal model of free circulation and a fundamentalist belief in art's belonging to a unique place. Indeed, like Conceptual Art, the most widespread "international style" to emerge since the mid-1960s, the contemporary ethics of cultural property hinges on *information*.[12] In response to a thriving

4. Ai Weiwei, *Installation Piece for Venice Biennale* (in collaboration with Herzog & de Meuron), 2008. Bamboo wood, 236.2 × 393.7 × 275.6 in. (600 × 1,000 × 700 cm).

trade in illicit antiquities, whose original archaeological context is typically undocumented, UNESCO established a policy in 1970 called the Convention on the Means of Prohibiting and Preventing the Illicit Import, Export and Transport of Ownership of Cultural Property. The convention posits a clear theory of archaeological value: "Cultural property constitutes one of the basic elements of civilization and national culture, and . . . its true value can be appreciated only in relation to the fullest possible information regarding its origin." Not only does the UNESCO convention stress informational value as "truer" than aesthetic value (in the very same year as two watershed exhibitions of Conceptual Art, "Information" at the Museum of Modern Art in New York and "Software" at New York's Jewish Museum, which also sought to redefine the work of art as a form of information), but its enforcement relies on a second genre of information: the thorough documentation of an object's "history"—a continuous chain of custody, its *provenance*.

In the course of the first decade of the twenty-first century, which witnessed legal actions such as Italy's prosecution of former Getty Museum curator Marion True for acquiring illegally exported antiquities, as well as the opening of the new Acropolis Museum as part of the Greek government's effort to persuade Great Britain to return the so-called Elgin Marbles (not to mention many less publicized scandals and campaigns), these repatriation debates have taken center stage. This

makes sense because what is at stake are the ethical—
and even moral—dilemmas that arise when cultural
properties are virtually freed from the limits of space
and time. Should images flow freely like currencies,
anywhere the market will take them, or should this neo-
liberal freedom be tempered by the values of cultural
identity whose most extreme expression is fundamen-
talist? Indeed, the repatriation debates implicitly define
three paradigms of cultural circulation—the *migrant,*
the *native,* and the *documented* object—each of which
possesses its own relationship to a site of origin, its
own form of value, and its own particular legal status in
terms that recall one of the most charged political issues
of our time—illegal immigration among migrant labor-
ers, and massive flows of refugees in war-ravaged parts
of the developing world (diagram 2).

The *migrant object* may have an inadequate prov-
enance that can be gradually legitimized by passing it
through a chain of owners: galleries, prominent col-
lectors, and, ultimately, museums. Its cultural value
lies in its *aesthetic* power, but legally it is owned as a
commodity—and the sovereign authority of prop-
erty rights may be used to mask its illegitimate prov-
enance. The "information" carried by migrant objects is
believed to be inherent in their form rather than depen-
dent upon their site of origin. In a controversial book
published in 2008, *Who Owns Antiquity? Museums and
the Battle over Our Ancient Heritage,* the current CEO of

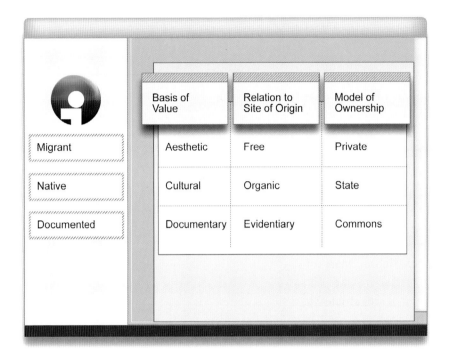

Basis of Value	Relation to Site of Origin	Model of Ownership	
Migrant	Aesthetic	Free	Private
Native	Cultural	Organic	State
Documented	Documentary	Evidentiary	Commons

Diagram 2. Designed by Geoff Kaplan.

the Getty Trust in Los Angeles, James Cuno, recounts his first visit to the Louvre as a college student:

> I was not the lesser for not being "from" these magnificent cultures. They were not inaccessible to me, though in many cases I had never heard of them and in every case knew little if anything about them. They were not foreign, in the sense of being of another's culture. They were mine, too. Or, rather, I was theirs. . . . And I looked at them in

wonder, too; in ways, I imagined, their original beholders looked at them.[13]

As Cuno's treacly account makes clear, with the "migrant object," the right of possession does not depend on either cultural commonality or special knowledge, but rather on pure empathy. Consequently, its relation to its original site may be easily severed in order to release it into free and unfettered markets.

The native object belongs organically to a specific place. While it may be of the highest aesthetic quality, its primary value is tied to a specific cultural identity, and typically it belongs—or is said to belong—to the state. Melina Mercouri, who was the Greek Minister of Culture and Sciences when Greece initiated its efforts to repatriate the Parthenon Marbles, declared in an address to the Oxford Union in 1986, "You must understand what the Parthenon Marbles mean to us. They are our pride. They are our sacrifices. They are our noblest symbol of excellence. They are a tribute to the democratic philosophy. They are our aspirations and our name. They are the essence of Greekness."[14] Native objects are absolutely site specific: if displaced they are said to be maimed, rendered meaningless.

Finally, there is the documented object, whose relationship to its original site or "find spot" (which is technically known as a provenience) has been properly studied to produce an informational or *documentary* value. Even

if such objects are removed from their place of origin and acquired by a distant collection, the knowledge derived from them—and thereafter represented by them—remains part of the cultural commons. For archaeologist John Carman, access to this kind of knowledge is a necessary but not sufficient public good. In his book *Against Cultural Property: Archaeology, Heritage and Ownership,* he rejects the ownership of cultural property in any form—whether by a nation-state or a museum—as inherently reducing material culture to nothing more than an economic asset that must be exploited: "This brings us finally to the core but unstated notion which sustains all of the value structures of the economic approach but which ultimately denies the ubiquity of the environment: that value only accrues to things that are in some sense, and in some way, *owned.*"[15] Carman advocates instead a collective form of community management of cultural heritage. As utopian as this position may sound, it is extremely salutary to imagine how material culture, and image cultures of all descriptions, may be valued differently than *as property.* Images might become forms of currency that do not conform to the *monetary* (like many forms of communication).[16] Because they emerge in an "information era" where documentation is virtually inherent in the production of art, contemporary artworks typically belong to the category of documented objects.

The question of art's circulation, or its *currency*—whether migrant, native, or documented—is thus

intricately tied to different understandings of its "site specificity." And it is Walter Benjamin, who has done the most to theorize twentieth-century mechanical reproduction, who has also produced the most enduring model of how art *belongs* to a place. Indeed, in his famous essay "The Work of Art in the Age of Its Technological Reproducibility," the dialectic I have identified between the "native" and the "neoliberal" is already encoded. (Perhaps that is why his influential theorization of art's site specificity in terms of *aura* is cited as compulsively today as it was when it entered the Anglo-American canon of the postmodern 1980s.) But Benjamin's essay can hardly account for the revolutions in image production and circulation initiated by media like television, the Internet, and mobile phones since its publication in the mid-1930s. His brilliant analysis has become a roadblock.

This problem is due not to Benjamin's failure but to our own. There is still no better analysis than his of the economic-aesthetic "regime change" that occurs when mechanical reproduction causes the unit of aesthetic analysis to shift from individual works to virtually unlimited populations of images. But in order to value the art of our own time adequately, we cannot indulge nostalgically in Benjamin's despair at the loss of aura:

> In even the most perfect reproduction, *one* thing is lacking: the here and now of the work of art—its unique existence in a particular place. It is this unique existence—and

nothing else—that bears the mark of the history to which the work has been subject. . . . The authenticity of a thing is the quintessence of all that is transmissible in it from its origin on, ranging from its physical duration to the historical testimony relating to it. Since the historical testimony is founded on the physical duration, the former, too, is jeopardized by reproduction, in which the physical duration plays no part. And what is really jeopardized when the historical testimony is affected is the authority of the object, the weight it derives from its tradition. . . . One might focus these aspects of the artwork in the concept of the aura, and go on to say: what withers in the age of technological reproducibility of the work of art is the latter's aura.[17]

According to Benjamin, aura results from *site specificity*. It is because the work of art belongs to a "time and space" that it can possess the authority of a *witness*. Reproduction jeopardizes "the historical testimony" and the "authority of the object." It eliminates distance in time and space by making the image nomadic. Aura is closely associated with image fundamentalism.

But as Benjamin was well aware, one of the primary aesthetic and political struggles of modernity has been the dislocation of images from any particular site, and their insertion in networks where they are characterized by motion, either potential or actual, and are capable of changing format—of experiencing cascading chains of relocation and remediation. Images are no longer and probably can never again be site specific, as Benjamin

diagnosed, which means that instead of *witnessing* history, they constitute its very currency. This is why the restitution debates I have discussed belong to our historical moment: they represent a fundamentalist effort to restore aura at a juncture when the potential of image circulation and the population explosion of images is irreversible. They are claims of rights to image wealth, often on the part of nations in the global South.

One of the most insidious aspects of Benjamin's influence is the enduring assumption that mechanical reproduction constitutes an absolute loss—and consequently that commodification, which is premised on large-scale mechanical reproduction, is the worst possible fate for any cultural content (despite the fact that it is the fate, to varying degrees, of *all* cultural content). There are gains as well as losses in the shift from singular artworks to populations of images that must be acknowledged before attempting to specify the changing formats of contemporary art. In their important book, *Ethnicity, Inc.,* John L. and Jean Comaroff theorize what they call the ethno-commodity, which packages lifeways or ethnic heritage into an image and/or product to be sold, sometimes as the only product a community may have to trade. Such commodification of identity is one of the primary crimes mechanical reproduction is accused of, involving, as Benjamin asserts, the loss of authority, history, and authenticity. The Comaroffs come to a dramatically different conclusion:

[T]he ethno-commodity is a very strange thing indeed. Flying in the face of many conventional assumptions about price and value, its very appeal lies in the fact that it seems to *resist* ordinary economic rationality. In part, this is because the quality of difference it vends may be reproduced and traded without appearing to lose its original value. Why? Because its "raw material" is not depleted by mass circulation. To the contrary, mass circulation reaffirms ethnicity—in general and in all its particularity—and, with it, the status of the embodied ethnic subject as a source of means of identity. Greater supply, in other words, entails greater demand.[18]

One could say, following the Comaroffs and contra Benjamin, that it is saturation through mass circulation—the status of being *everywhere at once* rather than belonging to a single place—that now produces value for and through images (and not only in "ethno-commodities"). Instead of a radiating nimbus of authenticity and authority underwritten by site specificity, we have the value of saturation, of being everywhere at once. In place of aura, there is *buzz*. Like a swarm of bees, a swarm of images makes a buzz, and like a new idea or trend, once an image (whether attached to a product, a policy, a person, or a work of art) achieves saturation, it has a "buzz" (diagram 3). A *buzz* arises not from the agency of a single object or event but from the *emergent* behaviors of populations of actors (both organic and inorganic) when their discrete movements are sufficiently in phase to produce coordinated action—when bees, for example, organize

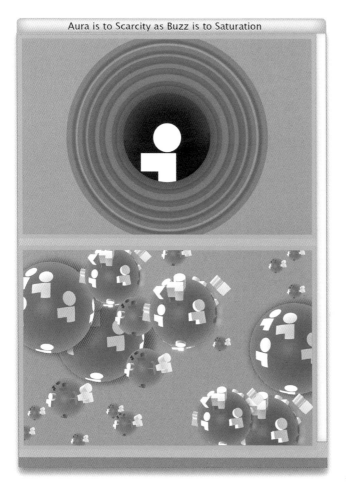

Diagram 3. Designed by Geoff Kaplan.

themselves into a swarm. Such events are not planned or directed by a single focused intelligence—they are "distributed" over several small acts that, taken individually, may have no intention, or consciousness of a bigger picture.[19] Buzz indicates a moment of becoming—a threshold at which coherence emerges.

Emergent or distributive forms are now recognized across a wide variety of fields:

- *In science:* Emergent behaviors or patterns, especially with regard to chaos theory, are among the most promising and popularly evocative scientific theories in the new century.

- *In political theory:* Since the publication of Michael Hardt and Antonio Negri's influential book *Empire* in 2000, the concept of the multitude constituted from extranational global movements of people—of migrants or refugees—has been linked to a special form of *political agency* whose demands are posed not to a particular state, but to the *globe*. Hardt and Negri's concepts are consistent with the importance of nongovernmental organizations and multinational corporations in producing emergent transnational communities, some devoted to philanthropy and others to pure profit.[20]

- *In distributed computing and information science:* The Internet would be impossible without the distribution of functional computing across networked clusters of computers situated in far-flung sites across the world. And like all distributed networks, these display a robustness that derives

from redundancy: you cannot disable the entire system by disabling individual nodes since there are many others available to take over their functions.

- *In popular culture:* Images of people and events multiply in magnitudes that cannot be planned or anticipated. Once there is a quantitative flashpoint, fads, trends, and celebrities generate news automatically: they are capable of autonomously multiplying their image.

- *In the art world:* Since the 1960s, artists have pursued strategies of image saturation appropriate to populations of images rather than inventing single works. Andy Warhol was the pioneer: he overproduced paintings in his "Factory" using photo silkscreen printing processes; he mastered media circuits previously external to the art world such as film, music, advertising, and performance; and he carefully cultivated his own personal celebrity. As he put it himself, Warhol was a "business artist" whose work encompassed a configuration of "product lines" rather than a succession of individual objects.[21]

The emergent image is a dynamic form that arises out of circulation. As such, it is located on a spectrum between the absolute stasis of native site specificity on the one hand, and the absolute freedom of neoliberal markets on the other. Its specific location on this spectrum—its particular quotient of nontransferable native content to commercial mobility—represents its

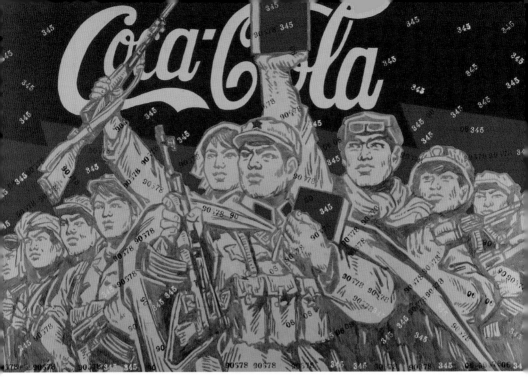

5. Wang Guangyi,
Coca Cola, 2004,
from Great Criticism
Series. Oil on canvas,
78.7 × 118.1 in.
(200 × 300 cm).

velocity as a cultural product. Take for example the first Chinese artists to gain prominence in the West—those associated with so-called Cynical Reason and Political Pop, such as Wang Guangyi (figure 5). His works, which often take twentieth-century Chinese political icons as their motifs, have the perfect formula for success in a global art world: they carry a quantum of native "Chineseness," but their mobilization of familiar Western art styles makes it possible for them to communicate this unfamiliar and even "exotic" content to a broad range of audiences with little knowledge of China. This

is what the contemporary global artwork must be: an emissary, whose power arises out of cultural translation rather than avant-garde innovation, a form of international currency that can cross borders effortlessly.

Instead of continuing to accumulate more and more artworks in the basements of museums proliferating across the developed world, we could take image diplomacy seriously and attempt to imagine how art can function as a currency without falling into monetization. This would involve making cultural politics a serious dimension of foreign policy, as the rightly maligned but highly effective United States Information Agency did in the mid-twentieth century.[22] Or it might involve regarding images as a global resource (which they are) and working toward global image justice, including the redistribution of image wealth between the global North and the global South. This is indeed the sort of wise suggestion made by art historian Irene Winter in her trenchant review of James Cuno's book, *Who Owns Antiquity?* Winter points out that Cuno's faith in the Encyclopedic Art Museum as a model of enlightened multiculturalism conveniently ignores inequalities between the developed and the developing worlds. It is worth quoting one of her examples at length:

> I speak here of the mounting by Stella Kramrisch of the *Manifestations of Shiva* exhibition at the Philadelphia Museum of Art in the 1980s. The government of India, under the Ministry of Education and Culture, made every

possible resource of staff and materials available to Philadelphia to ensure that the finest works of sculpture and painting be included in the exhibition. It was agreed that the Philadelphia Museum of Art would then make "comparable loans" available from its own collection. What the Philadelphia Museum actually offered was to loan back to India representative works of Indian art in its collection. The National Museum in New Delhi, however, already had a rather extensive collection of Indian art; what it desired was European paintings of high quality, particularly Impressionist works, that would provide a stimulating and inspiring experience for an Indian public. . . . The then director of the Philadelphia Museum . . . deemed such an exchange out of the question. So much for the third world's opportunity to exhibit the global artistic heritage.[23]

What if the U.S. State Department spent more time thinking about *cultural diplomacy* and less about making war; what if some of its budget and the budget of European *foreign ministries* (as opposed to often marginalized ministries of culture) made grants to modernize cultural infrastructures in the global South so that directors of institutions like the Philadelphia Museum of Art could never use inadequate facilities as an excuse for denying cultural exchange (this, after all, is what the Greek government did in building its new Acropolis Museum in Athens). And why is the vast majority of the cultural wealth in the industrialized world sitting in storage?

Indeed, the proliferation of museums worldwide, and the policies of stockpiling pursued by the richest of them, complicates the distinction I have made here between neoliberal and fundamentalist modes of circulation. I have argued that the former privileges the unlimited mobility of works of art while the latter is rooted in the conviction that works of art should remain in their place of origin. But the neoliberal position has its own form of conservatism verging on fundamentalism: the collection and conservation of works of art in museums, which replace the individual artwork's "natural habitat" by establishing cosmopolitan cultural centers—or central banks—to house them. This is the type of capital accumulation that museums speculate on through organizing national and international traveling exhibitions, globalizing their collections (as in the satellites of the Guggenheim Museum, the Louvre, and the Hermitage), and deriving significant profits from their holdings by reproducing them in souvenirs, publications, and authorized reproductions in museum stores. This is a currency of art that, as in hedge funds in the metropolitan West, has been hoarded and leveraged to benefit the few. I am advocating that we think more democratically about image circulation—that we begin to consider what a redistribution of *image* wealth might look like, and that we use the currency of art for purposes other than financial profit.

Populations

How then can we describe aesthetic objects as forms crystallizing out of a population, or currency, of images? Since the 1990s, architectural discourse has established an array of computer-enabled biological metaphors to theorize emergent form. These range from Greg Lynn's theorization of the biomorphic "blob,"[24] to the "Emergent Technologies and Design" program run by Michael Hensel, Achim Menges, and Michael Weinstock at the Architectural Association in London.[25] For Patrik Schumacher, partner and in-house theorist at Zaha Hadid Architects, this tendency has congealed into a style, *Parametricism*:

> Parametricism is a mature style. There has been talk about "continuous differentiation," versioning, iteration and mass customization etc. for quite a while within the architectural avant-garde discourse. . . . The shared concepts, computational techniques, formal repertoires, and tectonic logics that characterize this work are crystallizing into a solid new hegemonic paradigm for architecture.[26]

The question of Parametricism's "hegemony" has been a subject of lively debate among architects, who disagree over whether its design language—which is based on the scripting of variable systems through digital algorithms—may be considered a style whose signature aspects would be an undulating topographical

field composed of modular geometric elements, or whether the digital modeling capacities that Parametricism relies on should remain *tools* for designing a more materially based and responsive form of architecture. Sanford Kwinter, for instance, has identified what he sees as the temptation to render parametric design little more than a "look" in terms of what he calls "the 'parametric blanket' (. . . because these works resemble a featureless blanket thrown over a highly articulated traditional workshop model)."[27]

Whether such algorithmic fusions of computer modeling and neo-Darwinism lead to forms that genuinely emerge from the conditions of a site, program, and budget, or whether they are merely a trendy appliqué, depends upon the particular architect in question. What is important for our purposes is that architectural theory and practice of the past two decades has attempted to hone methods for generating "objects" from fields. This architectural discourse initially gained prominence through an influential 1993 issue of the journal *A.D., Folding in Architecture*, edited by Greg Lynn (figure 6). As an aesthetic act, *folding* is a powerful rebuttal to what theorist Jeffrey Kipnis understood to be the preceding dominant paradigm of architectural composition: collage, as popularized in the historical pastiche of postmodern architecture.[28] While collage multiplies and disorients the stable relationship between a figure and a ground, it does not abolish it, whereas folding,

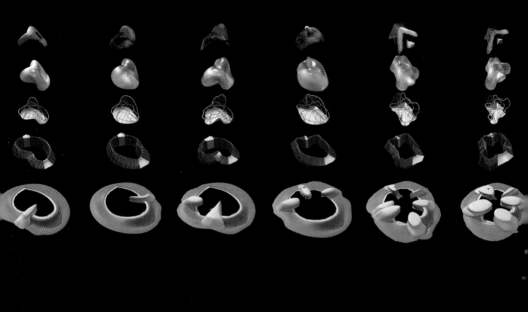

6. Greg Lynn,
Embryological House,
1998–99, rendering
(illustrated, p. 285 of
his recent monograph,
Greg Lynn Form).

whose concept of form is no more (and no less) than a disruption in a continuous surface, precisely stages the *becoming* of form through variable intensifications and manipulations in a continuous structure. Moreover, folding, like the computer technologies with which it is typically allied, is scalable: not only can it generate a building's plan through the modulation of structural members, but it is a technique for folding the site into the building and the building into the site. As Lynn writes, blobs are surfaces that turn into objects by sticking to their surroundings:

They do not ingest material into an interior cavity, but like a single-cell organism, stick to things that are then slowly incorporated through their surface. . . . The blob is all surface, not pictorial or flat, but sticky, thick, and mutable. . . . Blob form is determined not only by the environment but also by movement. . . . The term *blob* connotes a thing which is neither singular nor multiple but an intelligence that behaves as if it were singular and networked but in its form can become virtually infinitely multiplied and distributed.[29]

The blob is more than a biomorphic shape: it is a surface alternately undergoing intensification and relaxation, stickiness and smoothness, singularity and multiplicity. In other words, it is a continuous field, experiencing pressure from both site and program.

More recently, research into surface intensities among architects has centered on two formats: continuous ramps and differential fields. Even the most recalcitrant of spatial divisions—the articulation of multistory buildings as stacks of discrete floor plates—has been undermined through a tendency to design buildings as continuous platforms that may dip down from one level to another, as in Rem Koolhaas's New York Prada store, or spiral up as a continuous ribbon as in the stacks of his Seattle Central Library, which allows the library's collection to be organized continuously according to the Dewey decimal classification system (figure 7). The extraordinary Yokohama International Port Terminal by

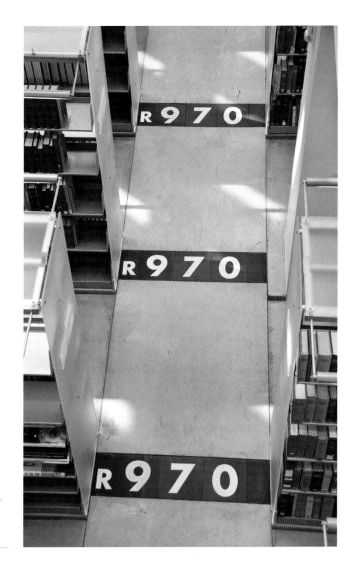

7. OMA, Seattle
Central Library, 2004,
view of walkway
with Dewey decimal
system.

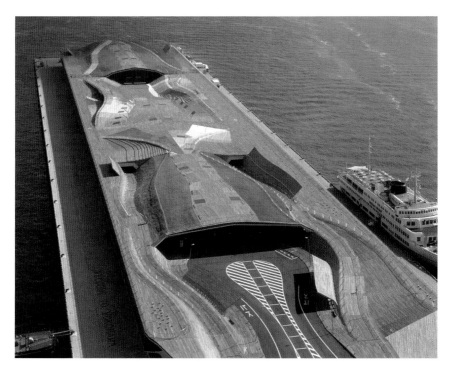

Foreign Office Architects (completed 2002) is an excellent example of a building designed to function as a topographical platform that braids together what formerly would have been considered its figure and ground, or building and landscape (figure 8). The now dissolved firm's principals, Farshid Moussavi and Alejandro Zaera-Polo, have described the terminal as a "warped surface" generated from a diagrammatic analysis of its circulation pattern. They write, "On a primary level, the

8. Foreign Office Architects, Yokohama International Port Terminal, 2002.

small blocks of program, shops, cafes, ticket desks, and control points were deployed as if they were furniture to be placed onto the warped surface, as if they were 'confetti.' So we would scan the resulting topography and detect areas where the flow of people would tend to be stagnant, to locate the furnished program in those areas, depending on their degree of 'slowness.'"[30] As is often the case with buildings rendered as platforms, architectural form is both derived from circulation patterns and aimed at regulating their velocity.

Hand in hand with this emphasis on platforms is the widespread reinvention of buildings as a differential field. While hardly the only architects to deploy such a rhetoric (this preference is evident in numerous prominent contemporary practices), the firm of Reiser + Umemoto are among the most eloquent in defining an architectural field characterized by differential intensities. In their *Atlas of Novel Tectonics* (2006), they declare,

> A gross figure-ground distinction, showing structure and infill, for instance, is insufficient. The transmission of effects across a field is impossible when a dialectical relationship occurs from the start. The different zones of structure and infill have first to be described as a field of similarity in order for them to register difference. This establishes them as densities in a common field gradient.[31]

Instead of a series of members assembled according to the forces of gravity, structure is here defined as a field undergoing gradations of intensification, as when

Reiser + Umemoto write, "[W]e deploy a continuous rod field with degrees of greater and lesser density, the denser areas acting in a column-like manner, displaying column-like traits" (figure 9).[32] No single architectural element—like a column—is fully independent under such a system, but rather a "column-function" emerges as densification within a continuous field—a network of varying intensities.

Reiser + Umemoto's method undermines the firm distinction between an architectural object and its site

9. Reiser + Umemoto Architects, Shenzhen Bao'an International Airport project, 2007.

by subsuming both figure and ground within a unified field of variable intensity where *function* inheres not in any single element but in systemic concentrations of elements. Artists have invented analogous strategies of aggregation and variation to demonstrate the behavior of images within populations. The crux of this effort is to shift the figure/ground dynamic from the internal composition of an artwork, to a broader oscillation between the work and its aesthetic environment. In Sherrie Levine's *Postcard Collage #4, 1–24* (2000), for instance, which includes twenty-four of "the same" romantic postcard of a seascape, individually framed and installed in a grid, the viewer must confront any single image in the company of twenty-three other copies (figures 10.a–b). If you slowly move from postcard to postcard and really *look*, something paradoxical happens: the experience of each picture is both the same as and distinct— spatially as well as temporally—from all the others. As Reiser + Umemoto would say, "A gross figure-ground distinction, showing structure and infill, for instance, is insufficient." Within their population, the postcards function as *both figure and ground*, since revisiting the "same" image a moment later or a few inches away is never quite the same, and it occurs against the "ground" of every other occasion of looking. A spectator is thus pulled in two directions at once: drawn in and pushed out of any single postcard (in order to see the next; to keep in motion to gauge difference if there is any), in a

10. Sherrie Levine, *Postcard Collage #4, 1–24*, 2000. Postcards and mat board, set of 24, each 16 × 20 in. (40.6 × 50.8 cm). (a) Installation view and (b) detail.

complex passage from the internal logic of the artwork to its framing network.[33] Like Minimalist sculpture, Levine's practice requires a spatialized form of reception in which the viewer's shifting position from place to place causes modulations in significance.

Levine's strategy of reproduction or reiteration marks a broader shift in emphasis among contemporary artists from individual or serial discrete objects to the disruption or manipulation of populations of images through various methods of selecting and reframing existing content. As in *Postcard Collage #4* these tactics underemphasize *what* is represented in order to accentuate the relationship between discrete images and their framing networks. Since the mid-1950s, four strategies for doing so have emerged:

- *Reframing found content in space* by incorporating pictures drawn from magazines, books, or the Internet into a variety of formats (often labeled *appropriation*); or purchasing objects ranging from picturesque junk to brand-new commodities to rearrange into configurations. Cildo Meireles's *Insertions into Ideological Circuits* (ca. 1970), for example, placed returnable Coca-Cola bottles back in circulations with oppositional slogans like "Yankees Go Home!" (figure 11).

- *Capturing content in time*, on film (as in Tacita Dean's *Fernsehturm*, 2001, which records the passage from day to night from a camera mounted on the platform of a rotating restaurant in Berlin) (figures 12.a–d), in Xeroxes, in digital

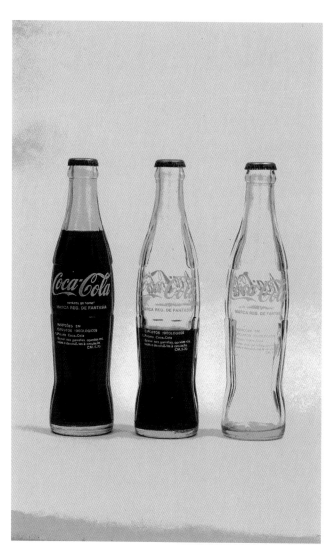

11. Cildo Meireles,
*Insertions into
Ideological Circuits*,
Coca-Cola Project,
ca. 1970.

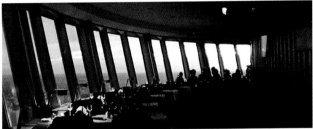
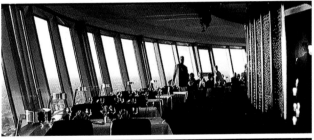
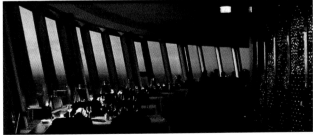

12. Tacita Dean, stills
from *Fernsehturm*,
2001. 16 mm color
anamorphic, optical
sound, 44 min.

photography and video, in text files, in live action, even some-
times in custom-made physical containers. This impulse
can be archival, documentary, or bluntly accumulative.

- *Reiterating content* in either live performance or "virtual
performance" (where images act as the sole protagonists
undergoing a change of state as when Rachel Harrison
gives mass-produced things like an ice tea can a new "envi-
ronment" in her *Tiger Woods* of 2006) (figure 13) through
rephotographing, refabricating, rewriting, restaging, and
reenacting a range of events including political protests,
works of art, or scenes from Hollywood films.

- *Documenting content through research* in order to create inge-
nious archival works that may function as nonnarrative—
and even fictional—documentaries, or impassioned
commentaries on a particular geopolitical site or situation,
as in Harun Farocki's *Immersion* (2009), which documents
some ways in which video game technologies are used
therapeutically by the American military (figure 14). Usually
such research is tied to revealing a hidden structure of a
place or situation, a practice typically associated with "insti-
tutional critique."

Each of these strategies is devoted to manipulating the
situational or performative nature of content rather
than inventing new content.

To account for this kind of art, it is not sufficient to
derive a "meaning" from either its ostensible content
or its formal structure. In the case of Levine's *Postcard*

13. Rachel Harrison, *Tiger Woods*, 2006. Wood, chicken wire, polystyrene, cement, Parex, acrylic, spray paint, video monitor, DVD player, NYC Marathon video, fake apple, sewing pins, lottery tickets, and Arnold Palmer Arizona Lite Half & Half green tea lemonade can, 79 × 48 × 43 in. (200.7 × 121.9 × 109.2 cm).

Collage, for instance, this would lead to two equally inadequate interpretations: either the patently ridiculous contention that the work is "about" the seascape that each postcard represents or the less absurd but still incorrect conclusion that it is "about" mechanical reproduction.

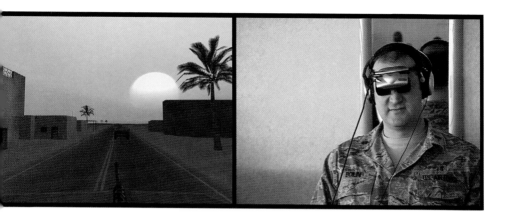

Both of these misreadings, the naïve and the sophisticated, fail to recognize that the work's power lies in its staging of a performative mode of looking through which the single image and the network are visible *at once*. In other words, as recalcitrant as it may seem, Levine's work requires *narration*. This is why even an artist as different from Levine in aesthetic sensibility as Matthew Barney may be compared to her on the basis of their shared procedure of recounting the social lives of images.[34] In Barney's elaborate thematically interlinked multimedia series *Drawing Restraint* and *The Cremaster Cycle*, for instance (figures 15, 16) objects function as protagonists in what amounts to an epic of things (this is why there is seldom any dialogue in his films since objects don't possess the capacity for speech). Barney's personal "mandala" or diagram of forces is encoded in

14. Harun Farocki, *Serious Games 1, Immersion*, 2009. Double channel video installation, 20 min., loop, detail.

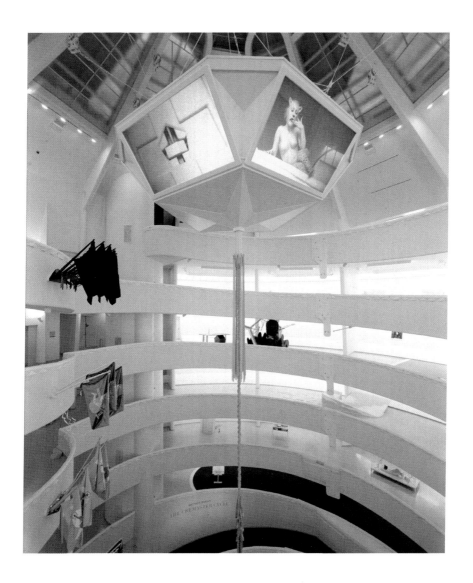

15. Installation view
from *Matthew Barney:
The Cremaster
Cycle*. Solomon
R. Guggenheim
Museum, New York,
February 21–June 11,
2003.

16. Matthew Barney,
detail from *Field
Suite*, 2002. Portfolio
of five etchings in
self-lubricating plastic
portfolio box, 15 3/4 ×
10 3/4 in. (40 × 7.3 cm)
paper, 17 3/4 × 13 ×
1 in. (45.1 × 33 ×
2.5 cm) box.

his own invented logo, the "field emblem," a horizontal oval shape upon which an orthogonal bar of repression is superimposed. According to the artist's system, this simple figure encompasses three dynamics whose shifting equilibrium he defines as follows: (1) *situation* corresponds to raw drive without direction; (2) *condition* is a "visceral funnel" corresponding biologically to the breakdown of food in digestion, or the breaking down and building up of muscle tissue through exercise and sport; and (3) *production* that the artist associates with anal output, in keeping with his penchant for biological metaphors, which not coincidentally break down a "person" into a field of unconscious physical and chemical interactions. In many of Barney's works, however, production is blocked in order to retain the system's energy in a perpetual closed circuit.

The arcane niceties of this privatized biological network need not distract us from Barney's fundamental accomplishment: inventing an elaborate tournament of events for objects to undergo. In the case of his films and performances, things are wrapped, molded, hardened, personified, ingested, collapsed, and so on and on, as though put through every permutation and variation of the triple forces of the field emblem. In other words, the changes in format that objects undergo dictate Barney's narrative. At a moment when biology and biochemistry have become reigning social metaphors, he rechoreographs the biological mechanics of the body

in order to produce an operatic demonstration of the great unconscious hubbub that keeps us alive. Barney diagrams life as a drama of things. The field emblem is not the *meaning* of his work, but its *format*.

The shift I've indicated from an object-based aesthetics in both architecture and art to a network aesthetics premised on the emergence of form from populations of images, calls for a corresponding revision of critical methodology. Objects characterized by discernible limits and relative stability lend themselves to singular meanings—almost as though well-defined forms are destined to *contain* a significance like vessels. Emergence, however, unfolds in time: it must be narrated. Despite the changes wrought by contemporary art to art history's object of study, the preponderance of art-historical interpretation continues to depart from the presumption that objects are its fundamental units of analysis—even if it is recognized that since Conceptual Art, artworks have become unconventional and provisional sorts of things. I call these strategies centripetal because they establish meaning by moving inward toward a thing—the work—bolstering its primacy and stability. We can diagram these tactics topographically, by describing how different methodological approaches locate value in proximity to the art object (diagram 4):

- *Meaning lies behind the object:* This position represents the venerable tradition of iconography as practiced by such

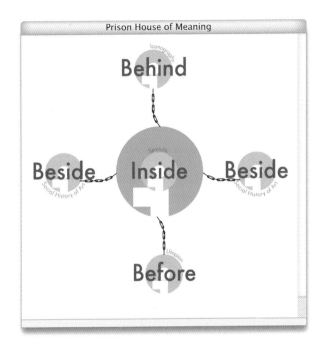

Behind

Beside Inside Beside

Before

art-historical luminaries as Erwin Panofsky.[35] Images *stand for* a set of cultural meanings that must be deciphered. Iconographic studies are a depth model of signification in which meaning lies behind the manifest forms represented and must be plumbed through erudite acts of reconstructive analysis drawing on such diverse disciplines as theology, history, and mathematics.

• *Meaning lies beside the object:* This is the position of the social history of art for which aesthetic products derive meaning through their crystallization of contemporaneous social

dynamics—including eventually the dynamics of gender and sexuality. The pioneers of this technique, such as T. J. Clark and Griselda Pollock, skillfully deduce cultural formations from close readings of art criticism in association with close analysis of works of art to determine interconnected formations in each.[36] But, topographically, meaning in the social history of art remains adjacent to the work; it surrounds it, and the historian wishes to fit the art object to this "context."

- *Meaning lies within the object:* This is the conviction of structuralist and poststructuralist art history mastered by Rosalind Krauss and Yve-Alain Bois.[37] Here, the significance of the artwork is attached to its manifestation of a semiotic logic. The value of the work is in its inner structure; the project of the critic is to bring this inner structure to light.

- *Meaning lies before the object:* Here is where the avant-garde tradition of utopia should be located. The work of art foretells an ideal future to come—a model that has recently regained the currency it had in early-twentieth-century avant-gardes such as Russian Constructivism or Dutch De Stijl through Molly Nesbit and Hans-Ulrich Obrist's Utopia Station project at the 2003 Venice Biennale, which the curators naïvely asserted could trigger significant social change.

These methods are centripetal because they are directed inward to the object as their organizing principle, even when ostensibly concerned with external phenomena like "context" or future effects. But by tethering things to meanings, such analysis participates in the very

processes of reification that the progressive wing of art history has devoted itself to critiquing. Assigning a meaning is merely another way of setting an artwork's price in the currency of knowledge, transforming it into a certain kind of commodity for collectors to buy and for museums to "sell" to their audiences.

In his influential concept of the architectural promenade, Le Corbusier offered a different model for encountering art that suggests a centrifugal versus a centripetal practice of interpretation. One of the most frequently cited accounts of the concept pertains to the house for an art collector. Here is Le Corbusier's description of the 1923 project for the attached Maisons La Roche–Albert Jeanneret in Paris (figure 17):

> These two houses joined in a single volume present two very different problems: one of them houses a family with children and includes several small rooms and all the services useful to the mechanism of a family. The other house is for a bachelor, the owner of a collection of modern painting and passionate about art. This second house will be rather like an architectural promenade. You enter: the architectural spectacle at once offers itself to the eye. You follow an itinerary and the perspectives develop with great variety, developing a play of light on the walls or making pools of shadow. Large windows open up views of the exterior where the architectural unity is reasserted.[38]

The architectural promenade gives form to a continuous modulation of vision through movement: a now

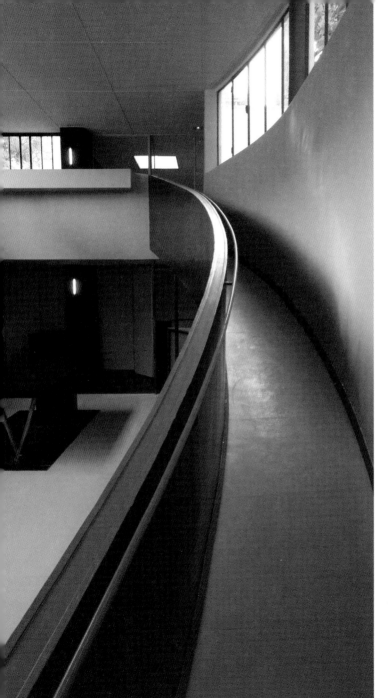

17. Le Corbusier,
Paris: Maison La
Roche, 1923. View
of ramp.

rising, now curving platform along which to proceed.[39]
Kenneth Frampton evocatively describes this effect as
"a topographic itinerary in which the floor planes bend
upwards to form ramps and stairs . . . fused with the
walls so as to create the illusion of 'walking up the
walls.'"[40] This centrifugal unfolding of architectural sur-
face as a platform for art is very different from the cen-
tripetal dynamic I have discussed in which meanings
from a *behind-beside-within-before* are directed inward
to bolster an object. Le Corbusier's topography (and its
diagrammatic or permutational legacy among contem-
porary architects) incorporates a concept—and a physi-
cal experience—of centrifugal vision, of what Gilles
Deleuze and Félix Guattari might call "lines of flight."

I think Pierre Huyghe had something like Le Cor-
busier's model of spatial unfolding in mind when he
defined his art as "a dynamic chain that passes through
different formats,"[41] or when he commented, "A film
is a public space, a common place. It is not a monu-
ment but a space of discussion and action."[42] In these
statements Huyghe asserts that a sequence of projected
images like a film may behave like a public space—a
commons, which resists the enclosure of meaning
that occurs when an artwork is assigned a centrifugal
meaning. In *The Third Memory* (2000), for instance,
Huyghe reconstructs the events of a notorious 1972
bank robbery and hostage situation in Brooklyn by John
Wojtowicz on which the 1975 film *Dog Day Afternoon*,

directed by Sidney Lumet, was based. When Lumet selected the story, it had already been filtered through several types of media (television, on which it was broadcast live, and publications such as *Life* magazine) (figure 18). Huyghe's reconstruction, interspersed with scenes from the film, is an attempt to capture Wojto-wicz's own memories through a reenactment staged on a replica of the movie set. *The Third Memory* thus charts a dynamic chain of formats—leading from a "true" story reproduced on television and print, to its fictional reenactment in a major Hollywood film, to its hybrid docudrama reconstruction. Populating his work with such a profusion of different formats establishes "a public space, a common space," by representing a filmed event as an ongoing crisis of representation—of endless reenactments and revisions. Lewis Hyde has recently defined a commons as "a kind of property (not 'the opposite of property' as some say)," and he elabo-rates by declaring, "I take 'property' to be, by one old dictionary definition, *a right of action*."[43] In other words, Hyde asserts that every form of property involves rights of action as well as limits on action. If one owns a house in the United States, for instance, one has the right to live or host a party there, but not to synthesize crystal meth or other illegal drugs in the basement. In Hyde's view, a commons does not dispense with such rights but stages several overlapping layers of rights to action: in a traditional British context, for instance, some

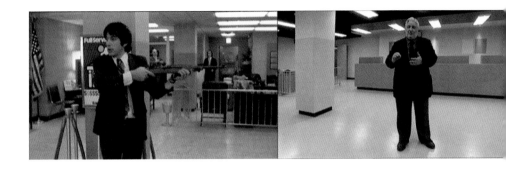

might have the right to graze their cattle in a commons while others are entitled only to gather wood there.[44] These limits to unbridled use are called stints. And, like a commons, a building or a work of art may *host several actions*, both actual and virtual.[45] Huyghe's *The Third Memory*, for instance, manifests an analogous process of "rights of representation" by superimposing different claims on the veracity of an event.

One way of giving form to spatial, centrifugal narratives—of producing, like Le Corbusier, a kind of "image promenade"—is thus to show how images may change their valence on account of their changes in position or that of their spectators. Levine pursues such a strategy by causing the viewer to move from one identical image to another; Barney submits his field emblem to various picaresque adventures, and Huyghe accomplishes a similar goal by projecting various "rights to representation" onto the same event. Another recent tactic for giving form to events within a field of

images is itself quasi-architectural—it consists of establishing actual open platforms, often with explicit reference to architectural structures, dedicated to hosting an array of activities ranging from actual events (involving human participation) to virtual events (implying the dislocation and relocation of objects). Rirkrit Tiravanija's *Secession* (2002) is a good example (figure 19). In it the galleries of the Vienna Secession accommodated an array of atypical activities, including the construction of a nearly life-size chrome-covered fragment of modernist architect Rudolf Schindler's canonical 1922 Los

Angeles house; allowing the galleries to remain open for twenty-four hours on Thursdays; and periodically scheduling "entertainments" like film screenings, DJs, and a big summer barbecue, as well as offering "therapeutic" Thai massage.[46] In different ways, these activities shifted the rights of action away from the museum as sole proprietor of its property and toward its users as shareholders: the *Secession* was reinvented as a contemporary version of a *commons*. Meanwhile, architecture itself, as embodied in Schindler's house, was submitted to spatial and optical dislocations, through the structure's reiteration in Vienna, and its sheathing in reflective chrome, causing it to become a kind of ghost.

The image commons imagined by Huyghe, Tiravanija, and many other contemporary artists seeks to format a set of links or connections—between people, images, spaces, events, and so on. These works do not proffer blank, undifferentiated spaces, but, like the historical commons according to Hyde, they establish a rich texture of rights to action or rights to representation. The patterns of connection such rights configure—their constellation of links—are what I call formats. Simply put, a format is a heterogeneous and often provisional structure that channels content. Mediums are subsets of formats— the difference lies solely in scale and flexibility. Mediums are limited and limiting because they call forth singular objects and limited visual practices, such as painting or video. Mediums are *analogue* in a digital world. Formats

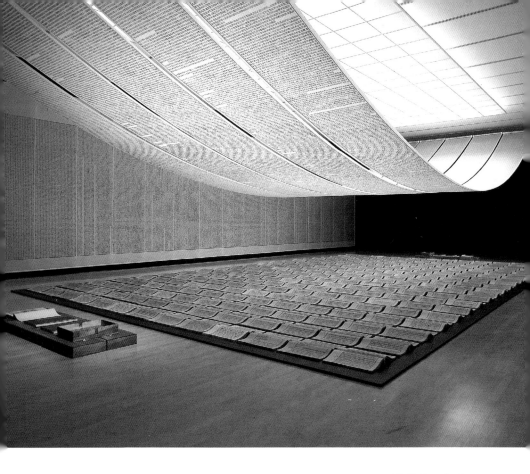

regulate image currencies (image power) by modulating their force, speed, and clarity. They can store such currency like a battery (as in Hanne Darboven's or Xu Bing's vast inscriptions of invented languages, or On Kawara's *One Million Years*, which records in notebooks an imaginary accumulation of time exceeding human comprehension) (figure 20). Or formats can stage extravagant

20. Xu Bing, *Book from the Sky*, 1987–91. Hand printed books, ceiling and wall scrolls printed from wood letterpress type using false Chinese characters, dimensions variable. Installation view at "Crossings," National Gallery of Canada, Ottawa, 1998.

21. Thomas
Hirschhorn, *Concrete
Shock*, 2006.
Installation shot
from "Superficial
Engagement,"
Gladstone Gallery,
New York, 2006.

expenditures, as in Thomas Hirschhorn's eruptions of pictures drawn from everywhere, frozen into igneous flows of misery and consumption or Isa Genzken's sharp stalactites of clotted stuff (figure 21). Formats can offer an empty platform for actions to emerge, as in Liam Gillick's structures resembling slick playgrounds designed by Donald Judd, or formats may furnish fantastic landscapes for prosaic commodities to develop new behaviors—new social lives—as in the work of Rachel Harrison. But in every case, formats like Le Corbusier's architectural promenade configure relationships spatially within a population of images.

Formats

Formats are dynamic mechanisms for aggregating content.[47] In mediums a material substrate (such as paint on canvas) converges with an aesthetic tradition (such as painting). Ultimately, mediums lead to objects, and thus reification, but formats are nodal connections and differential fields; they channel an unpredictable array of ephemeral currents and charges. They are configurations of force rather than discrete objects. In short, formats establish a pattern of links or connections. I use the terms *link* and *connection* advisedly because it is through such modes of association, native to the World Wide Web, that composition occurs under conditions of image population explosion. As I have argued, what

now matters most is not the production of new content but its *retrieval* in intelligible patterns through acts of *reframing, capturing, reiterating,* and *documenting.* What counts, in other words, is how widely and easily images connect: not only to messages, but to other social currencies like capital, real estate, politics, and so on. In economies of image overproduction connectivity is key. This is the Epistemology of Search.[48]

For Rem Koolhaas architecture is a form of data mining, so it's not surprising that in 2004 he published a chaotically organized book ironically titled *Content.*[49] In this kaleidoscopic, multigenre graphic novel/journal/luxury retail catalogue/retrospective, *content* is laid out like junkspace—the term Koolhaas invented to define an architecture of pure optimization—of time, money, and real estate. Spatially, junkspace is the "product of the encounter between escalator and air conditioning, conceived in an incubator of Sheetrock," and editorially, it is the collision of fiction and fact, commerce and philosophy.[50] Such unholy alliances are the architectural surrealism of our day; they are capitalism's automatism.[51] As Koolhaas declares, "Instead of design, there is calculation: the more erratic the path, eccentric the loops, hidden the blueprint, the more efficient the exposure, inevitable the transaction."[52] Koolhaas's own buildings visualize, and even intensify the erratic and eccentric pathways of junkspace (figures 22a–b). Through research, he reformats a program's content as

CONNECTIONS TIME

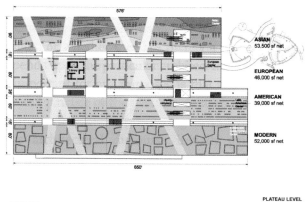

LACMA by OMA

PLATEAU LEVEL
total 210,000 sf

22. OMA and Rem
Koolhaas, bar charts
showing collection
plan, Los Angeles
County Museum of
Art Project, 2001.
"Collection Items,"
"Time Connections,"
"Typologies" from Rem
Koolhaas, *Content*
(2004), 128–29.

abstract charts and diagrams. But in designing build-
ings, he deforms this graphic *informational* architec-
ture, forcing its conventional rectilinear configuration
into new three-dimensional shapes, as in the Seattle

Central Library, where five functional platforms derived from programmatic analysis were knocked out of alignment to generate an arresting profile. In other words, Koolhaas reformats junkspace by giving it what Robert Somol has called a *shape* or what Alejandro Zaera-Polo calls "the politics of the envelope."[53]

Under an Epistemology of Search, as in Koolhaas's brand of design and Conceptual Art before it, aesthetics are redefined as the plasticity of information. Already in 1998, Google recognized the necessity of giving the vast reserves of data on the World Wide Web a shape, even in the absence of a viable business model for capitalizing on it. Now it is one of the most financially successful corporations of the early twenty-first century, and for a simple reason: in informational economies of overproduction, value is derived not merely from the intrinsic qualities of a commodity (or other object), but from its searchability—its susceptibility to being found, or recognized (or profiled). This explains why contemporary art marginalizes the production of content in favor of producing new formats for existing images, and it accounts for the strategies of a wide range of architects who generate space through the analysis and formation, or shaping, of data. These manipulations are the aesthetic analogue to Google's algorithms. Like such algorithms, art and architecture reformat existing streams of images and information. They practice both an epistemology and an aesthetics of the search engine.

Electricity is often colloquially called *power*—as when a city "loses its power" in a blackout. But this is more than a metaphor: all kinds of power share a structure with electric current. As with electricity, any *connection* comprises two moments: a point of contact and a current that is thereby established. This is the structure of connection: contact + current = currency (or power) (diagram 5). And connection is scalable—in other words a format may scale up from the intimate perception of a work of art by an individual, to the global circulation of images. There may be links based on adjacency and dizzying hyperlinks that jump across vast spaces and cultural differences. The critic's job is to trace them out—to demonstrate how patterns of links generate formats. This requires analyzing connection as a new critical object.

I will classify aesthetic links according to four different types of contact:

Work to Citizen
Community to Institution
Institution to State
State to Globe

These four types of links are the building blocks for *currencies* of image power. They create value through their magnitude and density of connections. While none of these types of connection ever exists in isolation, I will define them individually before considering how they function in combination.

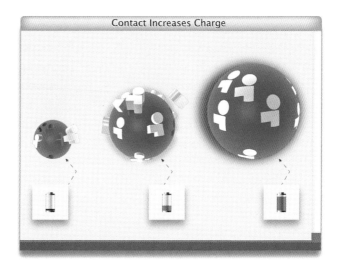

Contact Increases Charge

Diagram 5. Designed by Geoff Kaplan.

Work to Citizen

How does a work of art connect to a person? In the past several decades, art history has developed two models for this type of connection: the *perceptual*, which focuses on optical sensation as a form of knowledge, and the *psychological*, which attends to how works of art create dynamics of identification between persons and images. As valid as any other, these approaches are typically based on the spectator's self-possession of *her* experience as well as *her* subjectivity. Such a presumption of the self as *property* naturally corresponds to a type of artwork defined as property (which is the contemporary norm).

Instead of understanding how this special kind of property known as art can help viewers *possess themselves*, I wish to look at connection as itself an affirmative object of study—this is what I mean by asserting that there can be a currency of exchange that is not cash, but rather a nonmonetized form of *transaction*: translations between, for instance, different systems of value, or different cultures. Because I wish to acknowledge the significance of scalability—of multiple branching of connections that lead away from an individual to the locale, nation, and world—I use the term *citizen* to denote the integration of persons as responsible members of communities. I do not mean to refer narrowly to national belonging, but rather to a more flexible consciousness of responsibility to any group, any kind of public, from the most nascent to the most conventional.

In 2009 Cuban artist Tania Bruguera presented *Generic Capitalism* as her contribution to an experimental multiyear academic conference-cum-festival titled *Our Literal Speed* taking place in Chicago (figure 23). Some members of the audience were surprised to see Bruguera merely attending the work instead of participating directly since she had become known in the 1980s and 1990s for incorporating her body into her art. Notable among these early works were a series of reenactments initiated in 1986 of actions by the important feminist artist Ana Mendieta, also of Cuban descent, who lived in the United States from

1961 until her death in 1985. Mendieta's oeuvre ranged from implicitly traumatic pieces such as *Untitled (Body Tracks)* (1974), where she dragged her arms and hands, dipped in blood or paint, onto surfaces like paper, fabric, or the wall itself, to her quasi-ritualistic *Siluetas*, a series of anthropomorphic silhouettes, often set aflame, that became markers in the landscape. Bruguera, who splits her time between Cuba and the United States, sought to reinsert Mendieta into Cuban art history by revivifying her actions—thus staging a return of the older "exiled" artist to her birthplace. This was the first of Bruguera's many efforts to explore how the ephemeral effects of performance art may be remembered and represented both in the minds of individual audience members as

23. Tania Bruguera, *Generic Capitalism*, 2009. Detail of Bernadine Dohrn and Bill Ayers. Medium: Disruption of Public Spaces; technique: interrupted conference; materials: Weatherman underground members, planted performers in the audience, interruption of speech by the audience which takes over.

well as in museum collections through the purchase of archives and instructions for reenactment.

Generic Capitalism was another kind of work altogether—one more consistent with what Bruguera calls *Arte de Conducta*, or "Behavior Art," a practice to which she devoted a collaborative study center in Havana from 2003 to 2009 called the Cátedra Arte de Conducta. The purpose of Arte de Conducta is to rupture the membrane between art and life in aesthetic actions that have direct social impact. As the artist stated in an interview with performance historian and curator RoseLee Goldberg in 2004, "I want to work with reality. Not the representation of reality. I don't want my work to represent something. I want people not to look at it but to be in it, sometimes without even knowing it is art."[54] In *Generic Capitalism* spectators were indeed incorporated into the work as witnesses of a panel discussion including the 1960s Weather Underground activists Bernadine Dohrn and Bill Ayers, who in 2008 had again grown notorious due to the Republican Party's efforts to discredit Barack Obama during the presidential campaign by stressing his ties with Ayers, who was characterized as a dangerous radical. Inviting these charismatic and deeply ethical figures to address a largely politically progressive audience (which was drawn from the conference attendees as well as members of the general public) made for an exciting event, but it hardly posed a challenge to the political preconceptions of most people in the room. Dohrn is now

a law professor and director of the Children and Family Justice Center at Northwestern University, and Ayers is a distinguished education professor. Such complacency was ruptured, however, when a few audience members began to make aggressive challenges to both Dohrn and Ayers, and by extension to the presumed political consensus that held in the auditorium. The one-time radicals were accused of not being radical enough by some and of being out of touch by others. This atypical eruption of real dissent and impassioned discussion in an art event was highly bracing and led to one of the most stimulating and lively discussions that many in the audience could remember—a true instance of democratic debate in action.

It later came to light that Bruguera had planted the most outspoken questioners, unbeknownst to Dohrn and Ayers, who were themselves visibly taken aback by the vehemence of their interlocutors. What had felt like a spontaneous and explosive conversation had therefore been manipulated, which led to another, unmanipulated, but equally impassioned discussion at the symposium the next day where several participants expressed their feelings of betrayal that the discussion had been fixed.[55] In *Generic Capitalism* Bruguera successfully brought art into life not by introducing some external political content into the framework of art, as she seemed to be doing by inviting Dohrn and Ayers to participate as her guest "performers," but rather by

confronting an "insider" audience with two sorts of assumptions that implicitly tied them together—first, a presumed agreement on basic political positions and, second, the trust that public interchange will be free and disinterested rather than manipulated by the artist (or anyone else). In other words, Bruguera was not "preaching to the converted" by reconfirming the liberal assumptions of an audience presumed to be liberal. Instead, she was making these unconscious assumptions painfully visible, while simultaneously introducing manipulation into an occasion putatively governed by free speech. Perhaps this presence of manipulation amid an "imagined community" (the term is Benedict Anderson's)[56] is why Bruguera titled the work *Generic Capitalism*, for in a market economy where, for instance, "air time" on radio, television, and even increasingly on the Internet must be purchased, speech is vulnerable to manipulation by those with the means to purchase it.

In short, Bruguera's "Behavior Art" is much more specific than a generalized participation or interactivity between the audience and a work of art. It delineates the ties that bind particular audience members together rather than their simultaneous, but nonetheless individual connections to an image, object, or event (the latter functioning in this work as a pretext for clarifying the interpersonal relationships of the audience rather than an end in itself). In other words, Bruguera's work explores the nature of social ties or associations; in effect, it is this

web of connections that constitutes her format. In this regard, though it has not been explicitly categorized in this way, Arte de Conducta might be understood in light of what the French curator and critic Nicolas Bourriaud has influentially identified as Relational Aesthetics. In a statement that resonates with Bruguera's work, Bourriaud writes, "Each particular artwork is a proposal to live in a shared world, and the work of every artist is a bundle of relations with the world, giving rise to other relations, and so on and so forth, ad infinitum."[57]

Bourriaud's phrase "bundle of relations" is particularly apt and helpful. But for my purposes the term *bundle* needs further specification: I prefer thinking in terms of a *format of connections* rather than a bundle of relations. In *Generic Capitalism* Bruguera's format is as follows: she stages an event where a certain kind of trust and ideological commonality are assumed, and then she organizes their transgression—first, openly through hostile questioning and, second, clandestinely through manipulation (by planting those hostile questioners in the audience). Bruguera is not alone in exploring the relations of trust that compose art world communities, some casual and some highly formalized. Santiago Sierra is another, in his works like *Hiring and Arrangement of 30 Workers in Relation to Their Skin Color*, in which a group of workers, hired on the phone for an exhibition at the Kunsthalle Wien based on presumptions about their pigmentation, made on account of their

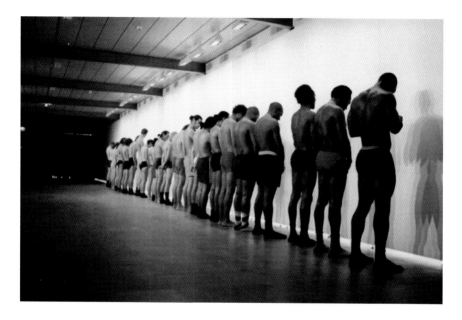

place of origin, were subsequently lined up and photo-graphed like a human color chart (figure 24). Yoko Ono and Marina Abramović have both invited audiences to approach them in ways that might easily become dan-gerous, and Tino Sehgal makes works that translate the viewing experience into a person-to-person interaction that sometimes embarrasses the viewer by directly call-ing attention to her presence in the midst of the work, and sometimes invigorates her with various modes of direct, semiscripted discussion.

I can't help thinking of Bruguera's title, *Generic Capitalism*, as a particularly apt category for all such works:

24. Santiago Sierra, *Hiring and Arrangement of 30 Workers in Relation to Their Skin Colour*, 2002. Project Space, Kunsthalle Wien, Vienna, September 2002. Photographs (diptych).

she stages interpersonal transactions premised on trust and aimed at producing value through collective knowledge. This is a speculation on the social—on the very possibility of producing different formats for public space. The currency exchanged in such situations may be cultural (and perhaps political as well), but we shouldn't forget, as critics often do, that such human "commerce" is one of the pillars of financial capital: witness *the art of the deal*. The currency of social interaction is indeed as *generic* as it gets.

Community to Institution

Thomas Hoving was hired in 1967 as director of the Metropolitan Museum of Art in New York, and he proceeded to "revolutionize" the venerable but dowdy institution by pioneering the blockbuster, a type of exhibition that helps museums capture entertainment and tourist revenues. According to his memoir, *Making the Mummies Dance*, Hoving stated his position during his very first meeting with the Met's curators:

> I want the museum to be humanistic. . . . Remember what Francis Henry Taylor [a previous director of the Metropolitan] used to say? That the Met is the "midwife of democracy." I want to use every device, every technique available for public education.[58]

Here is a paradox: The first exhibition Hoving organized in the service of this agenda was titled "In the

25. Marie Antoinette's dog house, included in the exhibition "In the Presence of Kings," Metropolitan Museum of Art, New York, April 18–June 11, 1967. Jean-Baptiste Claude Sené (1747–1803). Silk and velvet, gilded beechwood and pine, bearing the stamp of the Garde-Meuble de la Reine Marie Antoinette, c. 1775–80. 30 3/4 × 21 1/2 × 21 1/2 in. (78.1 × 54.6 × 54.6 cm), height of opening: 11 3/4 in. (29.8 cm). Gift of Mr. and Mrs. Charles Wrightsman, 1971.

Presence of Kings," which, as he recounts, included spectacular objects from the Met's collection that "are known to have been intimately associated with rulers,"[59] including "the blue velvet and gilt doghouse made for one of Marie Antoinette's puppies."[60] Hoving began a

revolution by exhibiting a sumptuous doghouse from the *ancien régime* (figure 25). What kind of revolution is this? What kind of democracy?

In 1993 the American Association of Museums (AAM) adopted a new Code of Ethics (revised in 2000) that more calmly echoes Hoving's flamboyant "royalist populism":

> Taken as a whole, museum collections and exhibition materials represent the world's *natural and cultural common wealth*. As stewards of that *wealth*, museums are compelled to advance an understanding of all natural forms of the human experience. It is incumbent on museums to be resources for humankind and in all their activities to foster an informed appreciation of the *rich* and diverse world we have *inherited*. It is also incumbent upon them to preserve that *inheritance* for posterity.[61]

This passage makes an explicit and repeated association between *wealth* (and its inheritance) and art—as though museums were banks—"image banks." The first use of this dead metaphor—*common wealth*—suggests a collective patrimony, and indeed, in the same document the AAM declares, "For museums, public service is paramount."

Here is a paradox: public service is elided with the accumulation of wealth. This connection—between accumulation and democracy—is the *format* of American museums. After all, the *common wealth* spoken of in the AAM Ethics Code is largely kept out of the

public eye in storage, and to visit that fraction of "public" collections that is on view typically requires a high admission charge. The museum connects democratic participation through its public programs and its populist rhetoric, to a structure based on primitive accumulation. This accumulation proceeds on at least three registers: the stockpiling of artworks; the collection of hefty financial donations from wealthy patrons in order to construct both buildings and endowments; and finally the accumulation of cultural prestige for those who participate in the museum's programs, but especially those at the top of the pyramid—the trustees—who accrue significant social advantages due to their philanthropic largesse.

In other words, the American museum is engaged in a massive money-laundering operation: turning finance capital into cultural capital and putting a democratic face on the accumulation of wealth—all exempt from taxes! This is the type of "currency" it speculates on. It is no wonder that artists like Bruguera take as their subject the ethics of dissimulation and betrayal. In her work, and other related projects, connectivity is demonstrated between people and things, and it establishes a consciousness of community. In the second register of connection exemplified by the museum, connectivity constitutes an exchange between a class of people (which may or may not share an official class designation such as, for example, a proletariat) and

an institution. For upper-class elites, museums justify accumulation as democratic; for large general audiences, the museum makes wealth fascinating, and hence culturally legitimate. It is no wonder that, in an era when the division between rich and poor has never been greater worldwide, museums are proliferating wildly.

Institution to State

In her book *Museum Branding*, available through the website of the American Association of Museums (AAM) and endorsed with great enthusiasm by former AAM Board chairman Freda Nicholson,[62] Margot A. Wallace offers a simple and powerful formula: "Branding becomes truly effective when all the museum's constituents hold the same indelible image of the institution."[63] This definition suggests a paradox: if the museum's brand should be unified, disciplined, and easily legible, its public mission is to multiply and complicate images—to collect, preserve, and display a wide array of artworks, each of which is in itself aimed at proliferating associations and customizing experiences for individual spectators. Branding museums thus involves gathering singular images into one exemplary "master image"—the brand.[64]

In truth, there is no paradox. Artworks and brands are positioned on the same continuous spectrum of gradations between two ideal poles: the absolutely

hermetic image, which has a connectivity quotient of 0, and the absolutely accessible image, with an infinite capacity to reach audiences. Neither of these ideal types exists in practice, but they define the range of accessibility that any image, whether commercial or not, can occupy. Within this spectrum, thresholds arise at points of saturation (i.e., of widespread connectivity) beyond which any image may begin to function as a brand. It is perfectly possible, as Andy Warhol and many others have demonstrated, for artworks to behave in this way—indeed, it is now impossible to build a truly global career as an artist without a high quotient of connectivity bordering on the status of a brand. It is a matter of degree, of the quantitative density of connections, that ultimately leads, as theories of emergence propose, to qualitative differences.

It is in buildings—and particularly high-profile projects designed to function as "three-dimensional logos"[65]—that the entire spectrum between hermetic object and brand is realized *as a structure*. In other words, in a widely celebrated building like the Guggenheim Bilbao Museum, designed by Frank Gehry, the mechanism of gathering many images (and functions) into one—of moving from the hermetic to the brand—is mapped out in space. The Guggenheim building is formatted like a knot. A roughly centrifugal configuration of curved and elongated gallery wings radiates from the structure's spectacular cynosure: its vertiginous atrium lobby

(figure 26). A conversation between Gehry and Barbara Isenberg clarifies the particular *architectural promenade* this building hopes to stage:

> BI: You made another unusual choice in the way the museum galleries come off the central atrium rather than lead one into another. My guide at the museum . . . said it had to do with your notions of democracy. She said you felt that nobody should be forced to go a certain way in a museum. . . .

> FG: It helps with museum fatigue and it gives you options. So, in a sense, it *is* democratic.[66]

The visitor is threaded in and out of the "eye" of the building—its iconic atrium space—as though all of her disparate experiences of artworks (along with her dramatic views of Bilbao's urban landscape) should refer back to the museum's central motif, its great central logo. The knot format *connects relatively hermetic images into the shape of a brand*. Nor is this an exceptional configuration for major late-twentieth- and early-twenty-first-century museums: Richard Meier's Getty Museum in Los Angeles exhibits many of the same principles, and Zaha Hadid's MAXXI Museum in Rome also ties up a bundle of long curved galleries into an atrium knot (though the format resembles a fiber-optic cable). Rem Koolhaas's CCTV building in Beijing is probably the greatest architectural knot of the early twenty-first century, bending its complex program into a huge iconic helix: an image of the void for

26. Frank Gehry,
Guggenheim Museum,
Bilbao, view of the
atrium, 1997.

the twenty-first century, which—whether ironically or innocently—was designed to represent China's mass media (figure 27).

In postindustrial "experience economies" whose growth is characterized by services ranging from tourism to finance, the branding of museums and other cultural facilities is a valuable—even essential—asset

27. OMA, view of CCTV building, Beijing (under construction). Courtesy CCTV.

for municipalities, regions, and nations. The Guggenheim was part of a long-term effort of planning and infrastructural development in Bilbao, which as a shipping and industrial center had experienced the deindustrialization and decline that many comparable regions around the world endured during the 1970s and 1980s. Between 1975 and 1996, for instance, the city lost almost half of its manufacturing jobs.[67] Relying on high-profile infrastructural and cultural developments is a typical strategy for addressing these problems, and indeed a new metro designed by Norman Foster and an airport addition by Santiago Calatrava, as well as an overall development plan for the Abandoibarra neighborhood by Cesar Pelli, were also essential components of Bilbao's redevelopment. The transportation projects, while greeting foreign and Spanish visitors to the city, were nonetheless much less effective in becoming attractive international symbols than the museum, which generated what has come to be called the "Guggenheim effect" (which the museum has attempted to transport to other cities around the world, notably Abu Dhabi).

In its first ten years, the Guggenheim Bilbao hosted ten million visitors, generating an income of nearly 1.6 billion euros. However, as Arantxa Rodriguez and Elena Martinez have pointed out in their analysis of Bilbao's revitalization, while the museum brings tourist dollars and service-sector jobs, its success in attracting

international development to help transform Bilbao into a regional financial center—which was the initial objective of the redevelopment plans—is inconclusive at best. Moreover, the authors express skepticism even with regard to the more limited goal of generating a sustainable local culture sector, in part because of the planning authorities' "narrow focus on consumption-oriented aspects and the disregard for the production-related aspects of the [Guggenheim Bilbao Museum] operation. A production-based strategy would require a more proactive policy of support for local firms and investment in the sector which until now has been missing."[68] The Guggenheim Bilbao assumes a format that leads from a diverse array of art objects to a singular branded architectural image whose purpose is to attract capital. Given the close connections between the world of finance and that of art, this speculation seems reasonable, but it only partially succeeded—bringing tourist income but not establishing Bilbao as a center of finance capital. State-sponsored cultural investment may be necessary but not sufficient to attain this goal.

Conversely, as I have already suggested with regard to China, avant-gardes outside the West have served an important function in incubating alternative public spheres that have the potential to be politicized. The underground practices of conceptualism served similar functions in the Soviet Union, as in China, and art worlds became sources of vocal dissidence in Cuba.[69]

Indeed, as Elizabeth Harney demonstrates in her work *In Senghor's Shadow: Art, Politics, and the Avant-Garde in Senegal, 1960–1995,* the arts have had a strong potential role in nation building throughout the period of decolonization.[70] For Senghor, establishing art worlds was a way of establishing Senegal itself.

State to Globe

As the very title of the groundbreaking 1995 book, *S,M,L,XL,* by OMA, Rem Koolhaas, and Bruce Mau succinctly asserts, in architectural design as in digital networks, scale matters. Scalability denotes a format's capacity to persist across increasing orders of magnitude. A connection's format—its structural articulation of contact and current—may be scaled up with minimal distortion, but the magnitude of current it carries—its *currency*—will vary, leading to quantitative differences. The relatively intimate and face-to-face connection between participants in Tania Bruguera's *Generic Capitalism,* for instance, generates a modest human currency (or power), which manifests itself as a subset of the art world, as opposed to the Guggenheim Bilbao's millions of visitors, which generate the power to produce an international image of cultural and economic regeneration as well as millions of euros in income for a regional, postindustrial city. In approaching the greatest scale of connection—between *state and globe*—the issue of scalability can no longer be ignored.

"Hits" and "cookies" are the keys to searchability online. The greater the scale of a network (in other words, the greater the extent of image saturation), the harder it is to retrieve any particular unit of information. Hits and cookies are the keys. Search engines like Google rank web pages according to the number of hits they receive. Numerous strategies for artificially boosting page rank have emerged, but they need not detain us here—what matters is density of connection. The more links there are, the more hits will occur. Cookies are small text files with an ID tag that are placed on computers by a website so that it can store information and recognize a user when she returns. Cookies are identity tags that facilitate recognition and retrieval.

The cultural profile of nation-states in a global economy also depends on hits and cookies. Saskia Sassen has argued that despite the commonsense assumption that globalization should lead to decentralization, world financial capitals such as New York, London, and Tokyo with their hyper-concentration of technological infrastructure and human talent (not to mention cultural amenities) have become ever more concentrated and dominant as the hubs or nodes within global networks.[71] Such global capitals profit from *densification*: a vast net of connections ranging from the fine-grained texture of urban neighborhoods to fast electronic links to locations around the world. To put it bluntly, New York gets more hits than Bilbao. This is why art fairs

and biennials have proliferated across the globe: they are gambits for cultural densification (which is always closely linked to financial densification). They are the stock exchanges of art where the world comes to speculate on cultural currency. As Donald Rubell put it, "People are now realizing that art is an international currency."

"Cookies," or identity tags, have also become essential in the global art world. Despite the onset of the lingua franca of Conceptual Art (in text, photography, video, and readymade assemblage), success as an artist—primarily but not exclusively outside the "unmarked" West—requires that a quantum of "Chineseness" or "Africanness" or "Russianness" be easily communicated in any particular work. Indeed, the globalization of readymades has made this kind of exchange relatively simple: if you are Subodh Gupta, include utensils native to India in your giant skull (figure 28); if you are Damien Hirst, inhabiting the world financial capital of London, choose diamonds instead (figure 29). Interestingly, the opposite seems to be the case when it comes to architecture, where figures like Frank Gehry, Sir Norman Foster, or Rem Koolhaas can bestow "legitimacy" on communities around the world through their structures.

Globalization, as defined by Immanuel Wallerstein,[72] requires a division of labor that is distributed worldwide: for instance, production of components for a particular product might take place in Mexico and

28. Subodh Gupta, *Mind Shut Down*, 2008. Installation view, Frieze Art Fair, London, 2008. Stainless steel and old utensils, 94 1/2 × 59 × 80 3/4 in. (240 × 150 × 205 cm).

29. Damien Hirst, *For the Love of God*, 2007. Platinum, diamonds and human teeth, 6 3/4 × 5 × 7 1/2 in. (17.145 × 12.7 × 19.05 cm).

Indonesia, to be assembled in the southern United States for a company whose headquarters is in Tokyo. We know that in the current global economy, development involves a progression from modes of production that have very low value added (such as sweatshop manufacturing) to very high value added (such as investment banking). India, for instance, has effectively moved a proportion of its economy up the ladder from production to services.

James H. Gilmore and B. Joseph Pine II, who made their names describing the so-called "experience economy,"[73] have recently asserted that the highest register of global economy is what they call the rendering of authenticity. Here is how they gloss this hierarchy, which was first introduced in their earlier book, *The Experience Economy*:

> While economists generally recognize three distinct economic offerings (commodities, goods, services) we discern two more, experiences and transformations:
>
> - *Commodities* are extracted from the earth—raised, mined, or harvested . . . and then exchanged in the marketplace as raw, fungible offerings
>
> - *Goods* are the tangible things manufactured from commodities
>
> - *Services* are intangible activities delivered on behalf of individual customers
>
> - *Experiences* are memorable events that engage individuals in an inherently personal way
>
> - *Transformations* are effectual outcomes that guide customers to change some dimension of self[74]

On all rungs of this ladder, from the lowest register of the commodity, which is extracted from the earth, to that of the transformation, whose target is the consumer's psyche, Gilmore and Pine see greater and greater degrees of customization. A "good" is a customized

commodity, a "service" is a customized good, an "experience" is a customized service, and a "transformation" is a customized experience.

Art and architecture are paradigmatic transformational experiences, and this is one reason why there have been such heated efforts in recent years among nations such as Italy, Greece, Egypt, and Peru to assert their cultural authenticity by demanding the return of "native" cultural artifacts held in foreign collections. It is also why contemporary art has become, for nations such as China, a means of soft diplomacy. As both commodity and experience, art is the paradigmatic object of globalization—it occupies the vanguard in an economy hungry for authenticity. Art establishes a special kind of currency exchange where cultural difference is assessed and traded like yen, renminbi, euros, and dollars. But art is never fully monetized. While there may no longer be an avant-garde on the model of the early twentieth century, neither is there a neo-avant-garde that simply repeats gestures of the early twentieth century. Images are not aimed at creating utopias; they have a diplomatic portfolio (and sometimes, as in embassies, they operate as infiltrators, as spies, as Trojan horses). In place of the avant-garde we have both monetized and nonmonetized forms of currency exchange. This is the *power* of connectivity under the Epistemology of Search.

Power

Like universities, the art world's institutions produce a wide spectrum of knowledge ranging from pure research to commercial applications. Universities train and employ experts and entrepreneurs who shape opinion in the realms of economics, government, the social sciences, and science. Academic economists, for instance, may exert broad influence as policy makers, including, notoriously, Jeffrey Sachs, who, as a professor at Harvard during the 1990s, advocated highly controversial "shock treatments" that rapidly liberalized markets in the controlled economies of formerly communist nations like Poland and Russia.[75] And the revolving door between politics and academe is well traveled—as exemplified by figures like Robert Reich, who has shuttled between positions in the Ford, Carter, and Clinton administrations and appointments at Harvard, Brandeis, and the University of California, Berkeley. In the realm of entrepreneurship, medical and high-tech research can generate significant revenue for universities like Stanford, the University of Pennsylvania, the University of Texas, or MIT, where laboratories serve as incubators for profitable start-up companies (Stanford's role in spinning off Silicon Valley is much envied and imitated by other universities). In the United States, if not worldwide, it is less

common for humanists to become influential public intellectuals, but the museum world, as a highly visible interface between broad audiences and art-historical research, can and does function as art's "university."[76] In museums, as in prestigious educational institutions, enormous wealth is combined with vast stores of knowledge.[77] This is a relatively old-fashioned model of information accumulation whose updated format is exemplified by Google. (In this regard, it is perhaps fitting that Facebook, the most successful online social network now in existence, started at Harvard, the richest university in the world.)

In museums then, art links vast amounts of capital to individual creativity and cultural identity. This particular format performs two profoundly important ideological tasks.[78] First, museums "launder" the assets of elites by transforming their private accumulation of art into public benefits for the "people." In other words, museums appear to democratize the uneven distribution of wealth that results from late capitalism's high-risk finance industries.[79] Museums themselves speculate on art in many ways—based on not only its literal value but also its many derivatives such as real estate investment, the proliferation of satellite museums or galleries, traveling exhibitions, souvenir merchandise, online retailing, expensive in-house restaurants, rights and reproductions, and publishing. Perhaps most profitably, art world institutions depend on art's capacity to attract

investment from wealthy individuals and corporations as well as government patronage.

The museum's second ideological project is aesthetic and philosophical. As an encyclopedia of artworks, it serves to validate and explore the status of images as a secular form of knowledge.[80] During the period of the museum's emergence and efflorescence as an institution—which corresponds to the modern period—artworks indeed changed dramatically in how they were consumed and assigned value. No longer were they cherished primarily for their capacity to make the absent present,[81] through, for example, their embodiment of ancestors and gods, or their staging of sacred visions. Rather, art began to be valued for its capacity to carry secular content: to manifest knowledge as aesthetic form. The epoch of modern art, whose origins might be located either in the longue durée spanning the Renaissance to the mid-twentieth century or, the more conventional periodization, beginning with the French Revolution, is what Hans Belting calls the "era of art."[82] What *preceded* this period according to Belting, was a world of *images*, which he defines as personages endowed with their own power and agency. With the advent of the "era of art" such animate images ceded their agency to the artists who made them, giving ample ground for the cult of artistic genius to flourish. The modern association of art with secular knowledge thus began in the Renaissance with the fusion of

formerly artisanal practices with humanist learning; it proceeded to the nineteenth-century discovery—often associated with Romanticism—that the bourgeois subject could speak her private needs, desires, and political convictions through art, and ultimately it erupted into the various endgame critiques of perception—often highly politicized—that the historical avant-gardes of the early twentieth century so thrillingly developed. It is important to underline here that an association between images and such secular, self-conscious forms of knowledge need not be mimetic. Nonobjective painting, for example, as practiced by artists as various as Kandinsky, Mondrian, and Malevich, was rich with content—with various types of philosophical and utopian meanings.

With *After Art* I hope to link the vast image population explosion that occurred in the twentieth century to the breakdown of the "era of art."[83] Under the conditions of ubiquitous image saturation, modern art's purpose as a vanguard for the promotion of and research into how images constitute secular knowledge—and particularly self-knowledge or the anthropological knowledge of others—lost its urgency since everyone who inhabits contemporary visual culture assumes the complex communicative capacity of images to be self-evident. As a consequence, "art," defined as a private creative pursuit leading to significant and profitable discoveries of how images may carry new content, has

given way to the formatting and reformatting of existing content—to an Epistemology of Search. The major consequence of this shift is that art now exists as a fold, or disruption, or event within a population of images—what I have defined as a *format*. Such occurrences may be as concentrated as the "repetition" that characterized Sherrie Levine's *Postcard Collage*, or as expansive as the Guggenheim museum's gambit to become an engine of development in cities around the world ranging from Bilbao to Abu Dhabi. In fact, as I have argued, we shouldn't regard these links as mutually exclusive. Art can establish a wide variety of connections simultaneously: *after* art comes the logic of networks where links can cross space, time, genre, and scale in surprising and multiple ways.

If from one perspective the art world's structure recalls higher education, from another it resembles the film industry as a highly capitalized, well-organized form of visual entertainment. Like other entertainment industries, the art world is equipped with a sophisticated distribution network (museums, kunsthalles, art fairs, biennials, and galleries; daily newspapers, websites, and countless specialized magazines) and the capacity to draw large audiences to view major permanent collections and blockbuster exhibitions. Like entertainment industries, the art world exercises significant economic clout, presses nationalist claims, and has a tendency to concentrate production in world

megacities. If, on the one hand, the museum's organization as a quasi-university exemplifies modern art's project of producing visual knowledge, its proximity to entertainment corresponds to a second major ideological project: modernism's gambit to become a reservoir of alternative image worlds. This utopian dream motivated a broad spectrum of nineteenth- and twentieth-century artistic strategies spanning the opposing poles of escapist fantasies at one extreme and radical political utopias on the other. Once again, however, this utopian capacity of modern art, like its epistemological research into the status of the image, has been outflanked. In a world saturated with highly sophisticated entertainment industries including computer games, websites like YouTube and Vimeo, phones and tablets that perform as mobile multimedia platforms, films, and television, not to mention the enhanced capacity of travel and tourism by which the desire for exotic experiences is projected onto foreign cultures, art is just one of many producers of alternative realities

This is not to say that art is over—such would be the logic of the prefix *post*, rather than that of the more capacious prefix *after*. *After* may signify the kind of strategies of reproduction and recontextualization marked by Sherrie Levine's titles in works like *After Walker Evans*, in which she rephotographs (and reanimates) Evans's work. In its connotations of an "afterimage" or its implication of a life of images in circulation following

the moment of production, *after* posits continuity and reverberation, rather than rupture. What results after the "era of art" is a new kind of power that art assembles through its heterogeneous formats. Art links social elites, sophisticated philosophy, a spectrum of practical skills in representation, a mass public, a discourse of attributing meaning to images, financial speculation, and assertions of national and ethnic identity. Neither of the comparable industries I have mentioned—higher education and entertainment—assumes exactly this format. For example, the art world links valuable cultural capital associated with sophisticated philosophical discourse to mass appeal and bald financial power. Neither universities (whose links to finance are more discrete and whose public access is more limited) nor the film industry (whose purchase on high culture is tenuous at best) can quite accomplish this combination. This is to say that the specific format that art assumes lends it a unique form of power. The point is not to deny this power through postures of political negation or to brush it under the carpet in fear of "selling out." The point is to *use* this power.[84]

Much of the work categorized as institutional critique since the late 1960s parodies the power of art without either adequately defining it or coming close to actually extinguishing it. Asserting that a work of art is a function of the framing conditions of the museum (or other art world institutions) is certainly not false,

but it tends to accept the museum's ideological self-presentation on its own terms as a given rather than exploiting its complex format more creatively. To my mind the most effective pioneering works of institutional critique, such as Hans Haacke's *Shapolsky et al. Real Estate Holdings, a Real-Time Social System, as of May 1, 1971* (1971), which mapped the byzantine connections of ownership of dozens of tenement buildings in New York City through a maze of dummy corporations and partnerships leading back to the Shapolsky family, succeed by implying that art's power is necessarily negative or oppressive in its association with exploitative forms of property ownership. More recently, as Alexander Alberro argues in his introduction to an anthology of artists' writings on institutional critique, progressive artists have sought to bypass the art world altogether: "[G]roups such as ®™ark, RepoHistory, the Yes Men, subRosa, Raqs Media Collective, and the Electronic Disturbance Theater develop tactical media strategies to intervene effectively in an array of fields that are far removed from the institution of art."[85] In other words, according to Alberro and his coeditor Blake Stimson, the history of institutional critique proceeds from an initial excoriation of the art world's corrupt power to an implicit dismissal of that same set of art institutions as politically irrelevant. This leads to a blatant critical contradiction: either art's power is ethically corrupt or its power is nonexistent. As a corollary to this,

there is a lingering tendency to regard art's power as *virtual*—as an epiphenomenal reflection of other kinds of "real" power, such as capital. I have tried to demonstrate that, on the contrary, the organization of the art world—its format—is as real as it gets when it comes to capital's effects. It's not just the purchase of artworks, but the self-image of entire nations, the transformation of neighborhoods and cities, and the fashioning of diplomatic identities that art is capable of accomplishing. In fact, its power has probably never been greater.

Let me give an example of what I mean by using art's power affirmatively (and aggressively) rather than negatively or with shame. Ai Weiwei has *speculated* on the international profile he built through his notoriety in pioneering new exhibition models and working environments for artists in China and his success in the Western art world of museums, galleries, and biennials. His global reputation temporarily afforded him a certain cover for expressing dissident opinions, and he seized this opportunity—for instance, by continuing to post statistics about the death of young students in the inadequately constructed schools that were destroyed in the 2008 Sichuan earthquake on the blog he published between 2006 and 2009. It also led to his detention for eighty-one days in the spring of 2011 by Chinese authorities. Ai's political work did not result exclusively in objects, but in the exercise of power. At the same time, Ai has given form to the concept of the

population—of people and of things—in migration, as in his work for Documenta 12 in 2007 where he transported 1,001 Chinese, many of whom had never left the country, to Kassel, Germany, along with 1,001 chairs dating from the Ming and Qing dynasties that stood in as mute surrogates—as goods—for the Chinese tourists who were probably invisible as individuals to most visitors to the exhibition. In *Fairytale*, Ai did not critique the power of images—he *exploited* the power of art to transport people and things both spatially and imaginatively. This is our political horizon, *after art* (figure 30).

Not every artist has the opportunity and capacity to speculate on art's power exactly as Ai has done, but all can—and I think *should*—do so in some way. I have stressed the importance of image populations because I believe image power—the capacity to format complex and multivalent links through visual means—is derived from networks rather than discrete objects. This means that works of art must develop ways to build networks into their form by, for example, *reframing, capturing, reiterating,* and *documenting* existing content—all aesthetic procedures that explicitly presume a network as their "ground." Hannah Arendt has made a crucial distinction between power and violence, relevant to the power of images. In her important essay "On Violence," she writes, "*Power* corresponds to the human ability not just to act but to act in concert. Power is never the property

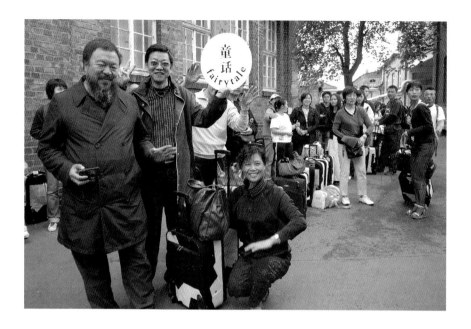

of an individual; it belongs to a group and remains in existence only so long as the group keeps together." This is distinct from violence, which she defines as "distinguished by its instrumental character. Phenomenologically, it is close to strength, since the implements of violence, like all other tools, are designed and used for the purpose of multiplying natural strength until, in the last stage of their development, they can substitute for it."[86] If we apply what Arendt says about human collectivities to populations of images, we discover a theoretical foundation for my assertion that

30. Ai Weiwei, the last group of 1,001 Chinese people who attended Documenta 12, as part of *Fairytale*, 2007.

connectivity produces power. One need not exit the art world or denigrate its capacities. Instead, we must recognize and exploit its potential power in newly creative and progressive ways. Our real work begins *after art*, in the networks it formats.

Notes

1. Ian F. McNeely with Lisa Wolverton, *Reinventing Knowledge: From Alexandria to the Internet* (New York: Norton, 2008), xv.

2. See Guy Debord, *The Society of the Spectacle*, trans. Donald Nicholson-Smith (New York: Zone Books, 1995). One of very many examples of "the spectacle" being taken as a monolithic force by critics on the left is Retort (Iain Boal, T. J. Clark, Joseph Matthews, and Michael Watts, *Afflicted Powers: Capital and Spectacle in a New Age of War*, new ed. (London: Verso, 2006).

3. See Rosalind E. Krauss, *A Voyage on the North Sea: Art in the Age of the Post-Medium Condition* (New York: Thames and Hudson, 2000).

4. Arguably the most influential definitions of an *image* as the term is used currently in art history are those of Hans Belting and W.J.T. Mitchell. In *Likeness and Presence*, Belting states his definition explicitly in the Foreword: "[I]n the framework of this book, the image I am considering is that of a person, which means that I have chosen one of several possibilities. The image, understood in this manner, not only represented a person but was also treated like a person, being worshiped, despised, or carried from place to place in ritual processions: in short, it served in the symbolic exchange of power and, finally, embodied the public claims of a community." *Likeness and Presence: A History of*

the Image before the Era of Art, trans. Edmund Jephcott (Chicago: University of Chicago Press, 1994), xxi. I would like to underline two ramifications of this argument beyond the important qualification of the image as the representation of a person: First, according to Belting this image is historically specific. It is the type of visual entity that exists before the modern understanding of art, or what he calls the "era of art." In other words it pertains to visual culture before the Renaissance. Second, this image is known through its "agency" as well as through the acts and aspects attributed to it by different constituencies (such as theologians, but also how images were used and abused popularly).

In *Iconology*, Mitchell, on the other hand, is at pains to insist that the image is culturally specific (though not necessarily premodern as in Belting's definition) and that it may be situated in a variety of disciplines, ranging from theology to literature, to science, to art, where it has significantly different meanings. This is what he calls a rigorous relativism. As different as these accounts seem on the surface they share two important qualities: first, that the image is based in history (though Belting periodizes it whereas Mitchell pluralizes it), and that the image possesses agency. Mitchell writes, "Images are not just a particular kind of sign, but something like an actor on the historical stage, a presence or character endowed with legendary status, a history that parallels and participates in the stories we tell ourselves about our own evolution from creatures 'made in the image' of a creator, to creatures who make themselves and their world in their own image." W.J.T. Mitchell, *Iconology: Image, Text, Ideology* (Chicago: University of Chicago Press, 1986), 9.

My definition of the image transposes these two fundamental qualities—historical specificity and agency—into terms relevant to a digital and global era of wild image proliferation. I will dwell on questions of remediation (or format) in the place of historical specificity; with regard to agency, I will argue that *populations* of images exercise the kind of power that Belting and Mitchell differently locate in the image as *personage*.

5. See James Gleick, *The Information: A History; a Theory; a Flood* (New York: Pantheon, 2011).

6. Carol Vogel, "The Buzz in Basel: Art, Alive and Well and Selling Briskly," *New York Times*, June 17, 2010, http://www.nytimes .com/2010/06/18/arts/design/18vogel.html?_r=1&scp=1&sq =the%20buzz%20in%20basel%20carol%20vogel&st=cse.

7. This is the artist Pierre Huyghe's description of his own model of objectivity, which I think could be expanded to encompass the nature of contemporary images *tout court*. George Baker, "An Interview with Pierre Huyghe," *October* 110 (Fall 2004): 90.

8. For a different perspective on these issues, see Sven Lütticken, *Idols of the Market: Modern Iconoclasm and the Fundamentalist Spectacle* (Berlin: Sternberg Press, 2009).

9. The art historian Wu Hung has argued that exhibitions are central to an understanding of contemporary Chinese art through their capacity to open small, temporary, but often virulent public spheres where an intellectual and artistic vanguard can incrementally broaden the scope of artistic freedom as well as political speech in China.

See, e.g., Wu Hung, *Transience: Chinese Experimental Art at the End of the Twentieth Century*, rev. ed. (Chicago: David and Alfred Smart Museum of Art, University of Chicago Press, 2005); and the "Exhibition Section" of Wu Hung, *Making History* (Hong Kong: Timezone 8, 2008), 157–215.

10. Richard Curt Kraus, *The Party and the Arty in China: The New Politics of Culture* (Lanham, Md.: Rowman & Littlefield, 2004), 28.

11. Indeed, I may be overemphasizing differences here where similarities are more significant. Many of the historical avant-gardes, including, for instance, Dada, the Bauhaus, De Stijl, and

Surrealism, were committed to an international effort to produce new forms of public perception and political action.

12. One might add identity politics and media strategies as equally international styles, but I would argue that these may also be placed in the genealogy of Conceptual Art.

13. James Cuno, *Who Owns Antiquity? Museums and the Battle over Our Ancient Heritage* (Princeton, N.J.: Princeton University Press, 2008), 156–57.

14. Address of Mme. Melina Mercouri, Minister of Culture and Sciences of Greece to the Oxford Union, June 12, 1986, http://www .melinamercourifoundation.org.gr/index.php?option=com_ content&view=article&id=73&Itemid=49&lang=en.

15. John Carman, *Against Cultural Property: Archaeology, Heritage and Ownership* (London: Duckworth, 2005), 73.

16. Ariella Azoulay has proposed the important idea of a "civil contract" of photography in which the implicit permission to both photograph and be photographed creates a civil society in and through images that is unrelated to the commodification of, for instance, an individual photograph. See Ariella Azoulay, *The Civil Contract of Photography*, trans. Rela Mazali and Ruvik Danieli (New York: Zone Books, 2008), esp. 85–135.

17. Walter Benjamin, "The Work of Art in the Age of Its Techno-logical Reproducibility," 2nd version, in *Walter Benjamin: Selected Writings Volume 3 1935–1938*, trans. Edmund Jephcott, Howard Eiland, et al., ed. Howard Eiland and Michael W. Jennings (1936; repr., Cambridge, Mass.: Belknap, 2002), 103–4.

18. John L. and Jean Comaroff, *Ethnicity, Inc.* (Chicago: University of Chicago Press, 2009), 20.

19. My arguments are clearly indebted to Bruno Latour's theorization of Actor-Network Theory. As an introduction to this method, see Bruno Latour, *Reassembling the Social: An Introduction to Actor-Network Theory* (Oxford: Oxford University Press, 2005).

20. See Michael Hardt and Antonio Negri, *Empire* (Cambridge, Mass.: Harvard University Press, 2000).

21. Warhol writes, "Business art is the step that comes after Art. I started as a commercial artist, and I want to finish as a business artist, After I did the thing called 'art' or whatever it's called, I went into business art. I wanted to be an Art Businessman or a Business Artist. Being good in business is the most fascinating kind of art." Andy Warhol, *The Philosophy of Andy Warhol (From A to B and Back Again)* (San Diego, Calif.: Harcourt Brace, 1975), 92. See also Isabelle Graw, *High Price: Art between the Market and Celebrity Culture*, trans. Nicholas Grindell (Berlin: Sternberg Press, 2009).

22. For an exemplary account of the United States's aggressive efforts to exploit the diplomatic potential of art, see Serge Guilbaut, *How New York Stole the Idea of Modern Art: Abstract Expressionism, Freedom, and the Cold War*, trans. Arthur Goldhammer (Chicago: University of Chicago Press, 1983).

23. Irene J. Winter, "James Cuno: *Who Owns Antiquity? Museums and the Battle over Our Ancient Heritage*" [book review], *Art Bulletin* 91, no. 4 (December 2009): 523.

24. See my discussion of blobs below.

25. See Michael Hensel, Achim Menges, and Michael Weinstock, *Emergent Technologies and Design: Towards a Biological Paradigm for Architecture* (Abingdon, UK: Routledge, 2010).

26. Patrik Schumacher, "Parametricism—A New Global Style for Architecture and Urban Design," *A.D. Architectural Design-Digital Cities* 79, no. 4 (July/August 2009): 15.

27. "A Conversation between Sanford Kwinter and Jason Payne," in *From Control to Design: Parametric/Algorithmic Architecture*, ed. Michael Meredith (Barcelona: Actar, 2008), 235.

28. See Jeffrey Kipnis, "Towards a New Architecture," in Greg Lynn, *A.D., Folding in Architecture*, rev. ed. (1993; repr., Chichester, UK: Wiley, 2004).

29. Greg Lynn, "Blob Tectonics, or Why Tectonics Is Square and Topology Is Groovy," in *Folds, Bodies & Blobs: Collected Essays*, 2nd ed. (Brussels: La Lettre volée, 2004), 170–72.

30. Foreign Office Architects, *The Yokohama Project* (Barcelona: Actar, 2002), 19.

31. Reiser + Umemoto, *Atlas of Novel Tectonics* (New York: Princeton Architectural Press, 2006), 93.

32. Ibid., 40.

33. For a related discussion of painting and networks, see my "Painting Beside Itself," *October* 130 (Fall 2009): 125–34.

34. I am alluding here to Arjun Appadurai's important and evocative category of the "social life of things." See Appadurai, ed., *The Social Life of Things: Commodities in Cultural Perspective* (Cambridge, UK: Cambridge University Press, 1986).

35. Erwin Panofsky, "Iconography and Iconology: An Introduction to the Study of Renaissance Art," in *Meaning in the Visual Arts* (Chicago: University of Chicago Press, 1955), 26–54.

36. See, e.g., T. J. Clark, *The Painting of Modern Life: Paris in the Art of Manet and His Followers* (New York: Knopf, 1985); and Griselda Pollock, *Vision and Difference: Femininity, Feminism, and Histories of Art* (London: Routledge, 1988).

37. See Rosalind E. Krauss, *The Originality of the Avant-Garde and Other Modernist Myths* (Cambridge, Mass.: MIT Press, 1985); and Yve-Alain Bois, *Painting as Model* (Cambridge, Mass.: MIT Press, 1990).

38. Le Corbusier and Pierre Jeanneret, *Oeuvre Complète de 1910– 1929*, new ed., ed. W. Boesiger and O. Stonorov with texts by Le Corbusier (Zurich: Editions Dr. H. Girsberger, 1937), 60.

39. For an important reading of Le Corbusier's notion of the architectural promenade in the context of mass media image culture, see Beatriz Colomina, *Privacy and Publicity: Modern Architecture as Mass Media* (Cambridge, Mass.: MIT Press, 1996).

40. Kenneth Frampton, *Le Corbusier* (London: Thames & Hudson, 2001), 79.

41. Baker, "Interview with Pierre Huyghe," 90. And indeed Huyghe collaborated with Michael Meredith to build a puppet theater at Le Corbusier's Carpenter Center at Harvard as the stage for his work, centered on the story of Le Corbusier's work there, *This Is Not a Time for Dreaming* (2004).

42. Ibid., 96.

43. Lewis Hyde, *Common as Air: Revolution, Art, and Ownership* (New York: Farrar, Straus and Giroux, 2010), 24.

44. See ibid., 27–28.

45. The Internet's capacity to disseminate information quickly and inexpensively has caused major legal actions and theoretical debates around the questions of copyright. This complex territory, which includes extensive restructuring of entire industries, is beyond the scope of this book. However, it's important to acknowledge one of the most prominent responses to these conditions, Creative Commons, which has attempted to develop a more open legal framework for sharing cultural property. On its website, Creative Commons makes the following statement: "The idea of universal access to research, education, and culture is made possible by the Internet, but our legal and social systems don't always allow that idea to be realized. Copyright was created long before the emergence of the Internet, and can make it hard to legally perform actions we take for granted on the network: copy, paste, edit source, and post to the Web. The default setting of copyright law requires all of these actions to have explicit permission, granted in advance, whether you're an artist, teacher, scientist, librarian, policymaker, or just a regular user. To achieve the vision of universal access, someone needed to provide a free, public, and standardized infrastructure that creates a balance between the reality of the Internet and the reality of copyright laws. That someone is Creative Commons" (http://creativecommons.org/about).

Lawrence Lessig, who was CEO of Creative Commons from 2001 to 2007, is one of the most prominent spokespeople for restructuring copyright restrictions, especially with regard to creative pursuits. See, e.g., Lawrence Lessig, *Free Culture: How Big Media Uses Technology and the Law to Lock Down Culture and Control Creativity* (New York: Penguin, 2004), and Lessig, *Remix: Making Art and Commerce Thrive in the Hybrid Economy* (New York: Penguin, 2008).

46. See Rirkrit Tiravanija, *Secession* (Vienna: Secession; Cologne: Verlag der Buchhandlung Walther König, 2003).

47. In my use of the term *format*, I am influenced and inspired by Bruno Latour's concept of the "assemblage." In theorizing

Actor-Network Theory, Latour is emphatic in asserting that there is no preexisting entity known as the "social." Instead, the social must be assembled, or constructed, through particular types of associations—this is what I call formats in the context of art. Indeed, this assembly has a quasi-visual or museal aspect for Latour: "So, to study is always to do politics in the sense that it collects or composes what the common world is made of." Latour, *Reassembling the Social*, 256.

David Summers also used the term *format* in his ambitious synthetic account of world art, *Real Spaces*. For Summers, the term indicates the articulation of virtual space with actual social space: "The encounter of an observer with a virtual space, before it is an encounter with a vast panorama or a furious battle [for instance], takes place before a culturally specific *format*—a screen, a polyptych or book, for example—in personal and social space." David Summers, *Real Spaces: World Art History and the Rise of Western Modernism* (London: Phaidon Press, 2003), 44. I have no quarrel with this definition; my own is simply meant to be even more heterogeneous.

48. In his influential book *The Long Tail*, Chris Anderson argues that in digital economies where everything is accessible (online, if not on the shelves of retail stores), the economic challenge is to make products accessible rather than available. His analysis has been fundamentally helpful to me in thinking through what I am calling "the epistemology of search." See Chris Anderson, *The Long Tail: Why the Future of Business Is Selling Less of More* (New York: Hyperion, 2006).

49. Rem Koolhaas, editor-in-chief, and Brendan McGetrick, editor, *Content* (Cologne: Taschen, 2004).

50. Rem Koolhaas, "junkspace," in ibid., 162. Koolhaas has published this essay in several places, making it a kind of signature manifesto.

51. The expression I have quoted recalls the Comte de Lautréamont's famous expression, beloved by the Surrealists, describing an encounter with a young boy as "beautiful as a chance meeting on a dissecting-table of a *sewing-machine* and an umbrella!" Koolhaas's fascination with surrealism was abundantly evident already in his *Delirious New York: A Retroactive Manifesto for Manhattan* (New York: Oxford University Press, 1978).

52. Koolhaas, "junkspace," 166.

53. According to Zaera-Polo, envelopes are more than a decorative membrane—they form the dynamic interface between a building's program and its site (an interface that, for him, is both *material* and *political*, technological and symbolic). As he puts it, "The particular interest in envelopes as political devices is that they constitute the element that confines a system and regulates the flow of energy and matter in and out of it." Alejandro Zaera-Polo, "The Politics of the Envelope: A Political Critique of Materialism," *Volume* 17 (2008): 104.

I think Somol means something similar by his term *shape*, as when he declares, "Shape is PROJECTIVE. . . . To radically paraphrase Carl Andre, a shape is a hole in a thing that is not." See R. E. Somol, "12 Reasons to Get Back into Shape," in *Content*, 86–87.

The term *projective* is crucial here, for in recent architectural discourse it signals a move away from "critique" (understood as identifying and undermining the spatial and social ideologies of architecture) to the cultivation of new urban possibilities—new platforms, or physical commons. In this regard, shape is not merely a building's profile but an active agent analogous to Zaera-Polo's envelope, capable of provoking and accommodating *new patterns of behavior*. As Somol and Sarah Whiting put it in their influential 2002 essay, "Notes Around the Doppler Effect and Other Moods of Modernism,"

Rather than relying upon the oppositional strategy of criti-
cal dialectics, the projective employs something similar to
the Doppler Effect—the perceived change in the frequency
of a wave that occurs when the source and receiver of the
wave have a different relative velocity.... If critical dialectics
established architecture's autonomy as a means of defin-
ing architecture's field or discipline, a Doppler architecture
acknowledges the adaptive synthesis of architecture's many
contingencies. . . . Rather than looking back or criticizing
the status quo, the Doppler projects forward alternative
(not necessarily oppositional) arrangements or scenarios.

Robert Somol and Sarah Whiting, "Notes Around the Doppler
Effect and Other Moods of Modernism," in *Constructing a New
Agenda: Architectural Theory 1993–2009*, ed. A. Krysta Sykes
(2002; repr., New York: Princeton Architectural Press, 2010),
196–97.

It seems more than a coincidence that the "projective" archi-
tecture of variable speeds (i.e., the Doppler Effect) is described
by its prime theorists as a *scenario*—the same term beloved by
artists involved in Relational Aesthetics such as Tiravanija. Enve-
lope, shape, scenario: all are means of formatting image currents.

54. RoseLee Goldberg, "Interview," in *Tania Bruguera* (Venice:
La Biennale di Venezia, 2005), 2.

55. For another eyewitness account and critical reading of this
work, see Carrie Lambert-Beatty, "Political People: Notes on
Arte de Conducta," in *Tania Bruguera: On the Political Imaginary*
(Milan: Edizioni Charta; Purchase, N.Y.: Neuberger Museum of
Art, 2009), 36–45.

56. See Benedict Anderson, *Imagined Communities: Reflections
on the Origin and Spread of Nationalism* (London: Verso, 1983).

57. Nicolas Bourriaud, *Relational Aesthetics*, trans. Simon Pleasance and Fronza Woods, with the participation of Mathieu Copeland (Dijon: Les Presses du réel, 2002), 22.

58. Thomas Hoving, *Making the Mummies Dance: Inside the Metropolitan Museum of Art* (New York: Simon & Schuster, 1993), 48.

59. Hoving is quoted in John McPhee, "A Roomful of Hovings," in *A Roomful of Hovings and Other Profiles* (New York: Farrar, Straus and Giroux, 1968), 62. In this profile Hoving also mentions Marie Antoinette's dog kennel.

60. Hoving, *Making the Mummies Dance*, 49.

61. American Association of Museums, "Code of Ethics for Museums" (2000), http://www.aam-us.org/, my emphasis.

62. Freda Nicholson, "Foreword," in Margot A. Wallace, *Museum Branding* (Lanham, Md.: AltaMira, 2006), 2.

63. Wallace, *Museum Branding*, 2.

64. For an important account of the convergence of art and architecture, as well as the rhetoric of the new global museum, see Hal Foster, *The Art-Architecture Complex* (London: Verso, 2011).

65. Wallace writes, "Signature buildings are three-dimensional logos, and beautiful new museums bring attention to their communities." Ibid., 42.

66. Barbara Isenberg, *Conversations with Frank Gehry* (New York: Knopf, 2009), 137–38.

67. See Arantxa Rodriguez and Elena Martinez, "Restructuring Cities: Miracles and Mirages in Urban Revitalization in Bilbao," in

The Globalized City: Economic Restructuring and Social Polarization in European Cities, ed. Frank Moulaert, Arantxa Rodriguez, and Erik Swyngedouw (Oxford: Oxford University Press, 2003), 182.

68. Ibid., 201.

69. See Sujatha Fernandes, *Cuba Represent! Cuban Arts, State Power, and the Making of New Revolutionary Cultures* (Durham, N.C.: Duke University Press, 2006).

70. Elizabeth Harney, *In Senghor's Shadow: Art, Politics, and the Avant-Garde in Senegal, 1960–1995* (Durham, N.C.: Duke University Press, 2004).

71. See, e.g., Saskia Sassen, *The Global City: New York, London, Tokyo* (Princeton, N.J.: Princeton University Press, 1991).

72. See Immanuel Wallerstein, *World-Systems Analysis: An Introduction* (Durham, N.C.: Duke University Press, 2004).

73. B. Joseph Pine II and James H. Gilmore, *The Experience Economy: Work Is Theatre & Every Business a Stage* (Boston: Harvard Business School Press, 1999).

74. James H. Gilmore and B. Joseph Pine II, *Authenticity: What Consumers Really Want* (Boston: Harvard Business School Press, 2007), 46–47.

75. For one cogently critical account of the "shock treatment" in Russia, dominated by International Monetary Fund policies as well as Harvard advisors, see Joseph E. Stiglitz, *Globalization and Its Discontents* (New York: Norton, 2003), esp. chaps. 5 and 7. Stiglitz argues that the Polish situation should not be confused with "shock therapy" since the government there adopted a mixed approach that included more gradualist policies.

76. The university function of art is developed in two additional ways: first, in the ambition of museums to be "universal"—to establish collections that have a broad purchase on art of the world. Obviously, only a minority of museums can pretend to this ambition, but all museums follow a second strategy of outreach and education for children and adults. In order to justify their massive accumulation of image wealth, museums have made themselves into educational centers.

77. I freely acknowledge that, as a tenured professor at Yale, I am implicated in such a system of knowledge and capital stockpiling.

78. It is often the case that contemporary artists who directly contradict the ideological tenets of the museum in general may exhibit in them with no damage done to the institution's overall point of view.

79. Admittedly, the model I am adopting here is largely based on American museums, which are generally privately funded (though officially "public" minded to the degree that they are granted tax-exempt status). However, the conclusions I am drawing are relevant to museums worldwide. In regions such as Europe, where museums tend to be publicly funded, their ideological messages are more closely related to nationalist agendas, which, as in the repatriation efforts in Greece and Italy, become absolutely explicit. In the developing world, the proliferation of new museums, often focusing on modern and contemporary art, has served purposes quite similar to those of American museums: they are typically the projects of wealthy private individuals who wish to assert their status as part of a cosmopolitan elite, or they are directly related to development projects. An excellent source of specific studies and general observations on the globalization of such a museum model is Hans Belting and Andrea Buddensieg, eds., *The Global Art World: Audiences, Markets, and Museums* (Ostfildern, Germany: Hatje Cantz Verlag, 2009).

Especially interesting are Savac Arslan's discussion of private museums founded by wealthy collectors in Istanbul, "Corporate Museums in Istanbul" (236–55), and Oscar Ho-Hing-kay's account of museums as a development amenity in Asia in his "Government, Business, and People: Museum Development in Asia" (266–77), where he makes the remarkable statement, "More museums are being built in Shanghai than Starbucks cafes" (266). In his introduction, "Contemporary Art as Global Art: A Critical Estimate," Belting argues that the Gulf States provide an excellent test case for how the art world may function as a tool of economic and cultural development (see 38–40).

80. For a history of the museum, see Andrew McClellan, *The Art Museum from Boulée to Bilbao* (Berkeley: University of California Press, 2008).

Michel Foucault encapsulates a theory of how museums validate works of art as knowledge in a single famous sentence, "Flaubert is to the library what Manet is to the museum." In other words, from the mid-nineteenth century, artists had to insert their work in the discourse of the museum, or, perhaps more accurately, they felt compelled to analyze and reorder the museum's collections within each single work of art. Foucault makes Manet sound remarkably similar to the artists from the past twenty years whom I am discussing (and undoubtedly this similarity is real). See Michel Foucault, "Fantasia of the Library," in *Language, Counter-Memory, Practice: Selected Essays and Interviews*, ed. Donald F. Bouchard (Ithaca, N.Y.: Cornell University Press, 1977), 92.

81. This is how David Summers defines images: "I will argue that, in the broadest conditional terms, images are fashioned in order to make present in social spaces what for some reason is not present. Images do not simply represent, rather they inevitably make present in determinate ways, situating, continuing, and preserving. Moreover, if images place or re-place the absent,

their uses are always defined by present purposes." *Real Spaces*, 252. Summers is talking about world art throughout history; I am arguing that there is a knowledge value that accrues to images during the modern period that differs from this presence/absence dynamic while not extinguishing it altogether.

82. See Belting, *Likeness and Presence*.

83. Making reference to Belting's *Likeness and Presence*, Arthur Danto's book, *After the End of Art: Contemporary Art and the Pale of History*, posits an end to the "era of art," which gathers steam in the 1960s and becomes widely intelligible by the 1970s and 1980s. For Danto, what defines the era of art is its production of historical and often teleological *narratives* of art (exemplified by Clement Greenberg's once hegemonic accounts of modernism) whose decline frees artists to do or make virtually anything as part of their aesthetic practice. My emphasis is less on what I see as Danto's typically postmodern diagnosis of the breakdown of grand narratives and more on how shifts in broad image economies—notably the image population explosion I have spoken of—change the potentialities and behaviors of art. The *after* of my title, unlike Danto's use of the prefix *post* in his preferred term, *posthistorical*, is meant to indicate both the reverberations of images as they spread (as in the term *afterimage*) as well as the patterns of circulation that emerge *after* images enter networks. Indeed, I believe we need to write *histories* of image circulation, of which *After Art* is a modest contribution. See Arthur C. Danto, *After the End of Art: Contemporary Art and the Pale of History* (Princeton, N.J.: Princeton University Press, 1997).

84. In this regard, my project is complementary to Boris Groys's effort to theorize the kind of power art exercises as political propaganda outside of market economies (including totalitarian states). Groys highlights the distinction between art's function in markets and its political power as ideological expression and

persuasion. I am trying to understand the complexity of art's power *within* market networks. See Boris Groys, *Art Power* (Cambridge, Mass.: MIT Press, 2008).

85. Alexander Alberro, "Institutions, Critique, and Institutional Critique," in *Institutional Critique: An Anthology of Artists' Writings,* ed. Alexander Alberro and Blake Stimson (Cambridge, Mass.: MIT Press, 2009), 15.

86. Hannah Arendt, "On Violence," in *Crises of the Republic* (New York: Harcourt Brace, 1972), 143, 145.

Credits

Permission to reproduce illustrations is provided by the owners and sources as listed in the captions. Additional copyright notices and photography credits are as follows.

1. © Silwen Randebrock. Courtesy Age Fotostock.

2. © Georgios Kefalas / Keystone / Corbis.

3. © Courtesy Peter Mauss / Esto.

4. © Luke Hayes / VIEW. Courtesy Age Fotostock.

5. Courtesy of Arario Gallery and Wang Guangyi Studio.

6. Courtesy of Greg Lynn Form.

7. © Chuck Pefley / Alamy.

8. Photo by Satoru Mishima.

9. Courtesy Reiser + Umemoto.

10. © Sherrie Levine. Courtesy Paula Cooper Gallery, New York.

11. Photo by Pedro Oswaldo Cruz. Courtesy Cildo Meireles.

12. Courtesy of the artist, Marian Goodman Gallery, New York / Paris and Frith Street Gallery, London.

13. Photo by Jean Vong. Courtesy the artist and Greene Naftali Gallery, New York.

14. © Harun Farocki 2009.

15. Photo by David Heald. © The Solomon R. Guggenheim Foundation, New York.

16. © Matthew Barney. Courtesy Gladstone Gallery, New York.

17. © 2012 Artists Rights Society (ARS), New York / ADAGP, Paris / F.L.C.

POINT: Essays on Architecture

Sarah Whiting

POINT offers a new cadence to architecture's contemporary conversation.

Situated between the pithy polemic and the heavily footnoted tome, POINT publishes extended essays. Each essay in this series hones a single point while situating it within a broader discursive landscape, and thereby simultaneously focusing and fueling architectural criticism. These short books, written by leading critics, theorists, historians, and practitioners, engage the major issues concerning architecture and design today. The agility of POINT's format permits the series to take the pulse of the field, address and further develop current issues, and turn these issues outward to an informed, interested public.